PATTERNS OF LIFE

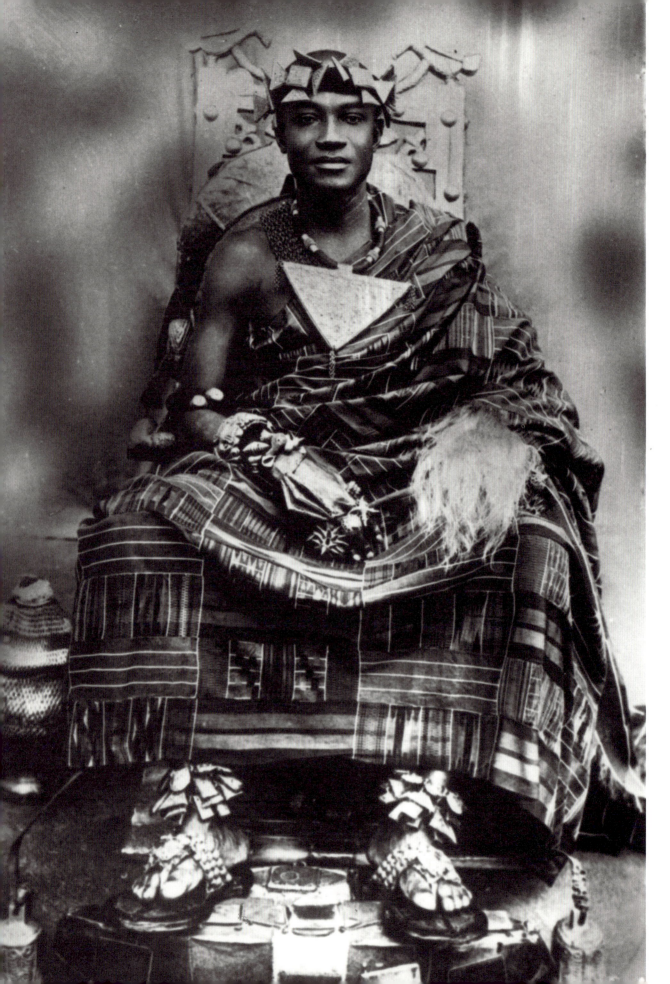

PATTERNS OF LIFE
West African Strip-Weaving Traditions

Peggy Stoltz Gilfoy

Published for the National Museum of African Art
by the Smithsonian Institution Press

Washington, D.C., and London

This publication and the exhibition it accompanies are supported by a generous grant from the Special Exhibition Fund of the Smithsonian Institution.

This book is published in conjunction with an inaugural exhibition, *Patterns of Life: West African Strip-Weaving Traditions,* organized by the National Museum of African Art.
September 28, 1987–February 29, 1988

Cover: Wrapper, Ewe people, Ghana (cat. no. 35).
Frontispiece: Otumfuo Osei Agyeman Prempeh II, K.B.E., Asantehene, attired in a magnificent *kente* cloth, Ghana, c. 1930.

Library of Congress Cataloging-in-Publication Data
Gilfoy, Peggy Stoltz.
 Patterns of life.
 Catalogue of an exhibition organized by the National Museum of African Art and held September 28, 1987–February 29, 1988.
 Bibliography: p.
 Supt. of Docs. no.: SI 1.2:L62/2
 1. Textile fabrics, Black Africa, West—Exhibitions. 2. Hand weaving—Africa, West—Exhibitions. 3. Men weavers—Africa, West—Exhibitions. I. National Museum of African Art (U.S.). II. Title. III. Title: Strip-weaving traditions.
NK8989.G55 1987 746.1'4'088042 87-43093
ISBN 0-87474-475-X (alk. paper)

Photograph Credits
Photographs were provided by the following:
Eliot Elisofon Photographic Archives, National Museum
 of African Art: figs. 6, 13, 14, 15, 20.
Fine Arts Library, Indiana University, Bloomington:
 frontispiece, figs. 4, 16.
Indianapolis Museum of Art: fig. 19.
Institute of Human Biology, State University, Utrecht:
 figs. 8, 9, 10.
Alastair Lamb: fig. 5.
Library of Congress: fig. 18.
National Archives: figs. 12, 17.

Contents

Foreword

This catalogue and exhibition devoted to West African strip-weaving traditions represents the culmination of several fortuitous collaborations concerning the acquisition of the collection and the involvement of well-known scholars of African textiles.

In 1982 two Smithsonian museums, the National Museum of African Art and the National Museum of Natural History, agreed to acquire jointly 1,500 West African strip-woven cloths from the collection of Venice and Alastair Lamb. The Lambs' systematic survey and field collecting of West African textiles have resulted both in a collection of beautiful examples and in accompanying documentation. The acquisition, made possible by the Smithsonian Institution's Collection Acquisition, Scholarly Studies, and Educational Outreach Program, was an excellent cooperative undertaking by two museums. During recent years, collection sharing has been endorsed and supported by the American museum profession. An agreement of this scope, aesthetic quality, and focus, however, was an extraordinary step, for it represents a highly effective use of financial resources and shared responsibility for preservation. It also assures multidisciplinary research and extends the privilege of exhibiting material of fine aesthetic merit. In 1982 Richard S. Fiske, former director of the National Museum of Natural History, John Reinhardt, acting director of the National Museum of African Art, and Charles Blitzer, then assistant secretary for history and art, were instrumental in bringing this acquisition to fruition.

Given this collection's strength, it was natural for the National Museum of African Art to organize a textile exhibition as a part of the inaugural plan for its new building. In such an endeavor much work precedes the final installation. The curatorial and registration staffs of both museums gave unstintingly of their time as the textiles were processed. Special thanks go to Mary Jo Arnoldi, curator of African ethnology, and Linda Eisenhart, museum technician, National Museum of Natural History; and Lee Williams, registrar, and Mary Lawson, formerly assistant registrar, National Museum of African Art. For their painstaking supervision of the conservation of the textiles, our appreciation extends to Stephen Mellor,

chief conservator, National Museum of African Art, and Cara Varnell, consulting textile conservator.

In November 1983 a Smithsonian Regents Fellowship was awarded through the National Museum of African Art to Renée Boser-Sarivaxévanis, former curator, Museum of Ethnology, Basel, Switzerland, to come to the United States to study the Lamb Collection and other textile collections in American museums. Her insight and expertise gave depth to her selection of fine examples for us to consider for the exhibition. Peggy Stoltz Gilfoy, curator of textiles and ethnographic art, Indianapolis Museum of Art, is responsible for the realization of the installation and the catalogue. We are deeply indebted to her for her enthusiasm for African textile traditions. It has been a great pleasure to have her as guest curator of this exhibition.

The exhibition drew upon the talents of many people on the museum's permanent staff as well. Our gratitude extends to Richard Franklin, chief of design, for his skillful installation; Dean Trackman, editor, who masterfully guided the editing of the catalogue; and Christopher Jones, graphic designer, for his beautiful design of the catalogue. Edward Lifschitz, curator of education, and Peggy Gilfoy recognized the importance of having an audiovisual component with the exhibition to ensure public understanding. They, along with Philip Ravenhill, chief curator, guided that important and highly technical component of the installation.

Before 1972 awareness of and interest in African textiles in the United States was limited to a small group of scholars and students. The turning point occurred in that year when Roy Sieber, now the museum's associate director for collections and research, conceived a major loan exhibition, *African Textiles and Decorative Arts*, at the Museum of Modern Art in New York City. His guidance has played an important part in planning this inaugural installation, and all of us are indebted to him.

The fragility of textiles demands that the greatest care be taken when planning an exhibition. The true splendor of a textile when reproduced in a catalogue is only revealed in color plates. A generous grant from the Smithsonian Institution's Special Exhibition Fund supported the conservation work, the exhibition, and the publication. We express our gratitude for this funding.

SYLVIA H. WILLIAMS
Director

Preface

Although today in America most textiles are considered convenient, ultimately dispensable materials, a result of the nineteenth-century industrialization of textile manufacturing, many non-Western cultures continue to regard their textiles as important expressions of cultural values. Marriages, funerals, and other rituals governing the physical and spiritual worlds require proper cloths. We, too, still attach emotional importance to some cloths, such as a child's blanket or a wedding dress. Textiles offer insights about a culture—they are linked to the fabric of cultural life.

A museum can be a vehicle for exploring other cultures through the textiles they create. Careful selection and presentation can provide a deeper understanding of certain aspects of another culture, and comparisons can be made among the materials, designs, and colors of textiles from different cultures.

The cloths in this catalogue and the exhibition it accompanies were woven on narrow-strip looms by West African male weavers. Most publications on West African cloth have focused on the technique of manufacture, especially the looms and the materials. Because this area is well covered, a historical, trade-oriented approach to the subject was chosen in order to examine the transmission of designs and ideas through the textile trade. The Introduction explains strip weaving. The essay "Patterns of Life" begins by discussing the history of both the trade from North Africa to the Guinea Coast along the trans-Saharan routes and the European oceangoing trade. The culmination of these two influences on sub-Saharan Africa is distilled in a section on Asante and Ewe cloths. Finally, the basic principles of composition in West African strip weaving are discussed. The "Catalogue of the Exhibition" provides specific information about each cloth, including a technical analysis.

The majority of the pieces in the exhibition come from a collection formed by Venice and Alastair Lamb between 1968 and 1972 when Alastair Lamb was head of the

History Department at the University of Ghana; subsequently, their collection was jointly acquired by the National Museum of African Art and the National Museum of Natural History. Four other pieces were selected from collections in the Smithsonian Institution. The textiles for the exhibition were chosen by Renée Boser-Sarivaxévanis while she was a Smithsonian Regents Fellow in 1985–86, and most of the attributions for the cloths are hers.

As with any project of the scope of this publication and exhibition, thanks go to many people who offered generous help. I am indebted to the Indianapolis Museum of Art, which allowed me time to carry out this project. Mattiebelle Gittinger gave me information on Indian trade cloths, and Rita Bolland and Rogier Bedaux offered insights into the Bandiagara cloths that I would not have otherwise obtained. In addition, various members of the National Museum of African Art have been responsible for unlimited help and encouragement. I wish to thank Sylvia Williams, director, and especially Roy Sieber, associate director for collections and research, for the opportunity to work on this project. It has been an intensely rewarding experience, and I appreciate their generous support. Philip Ravenhill, chief curator, brought fresh insight, scholarship, and superb organizational skills to bear on this project as a result of his intimate knowledge of West African weaving traditions. For the dramatically effective installation of the exhibition, I must thank Richard Franklin, chief of design. Dean Trackman, editor, spent many hours working on the text and checking the catalogue entries and bibliography, a project made even more difficult by my absence. Without him the final product would have been greatly diminished. The design of the publication was the responsibility of Christopher Jones, graphic designer, whose creative talents considerably enhanced the finished work. Textile conservator Cara Varnell provided fiber identification and offered other technical assistance during preparation of the technical catalogue entries. Judith Luskey, archivist of the museum's Eliot Elisofon Photographic Archives, and Jon Reel, formerly of the archives, helped to locate many of the photographs.

The last note of gratitude goes to Renée Boser-Sarivaxévanis, whose original work with this collection was immeasurably helpful. It is to her and her pioneering work on West African cloths and men's looms that this book is dedicated.

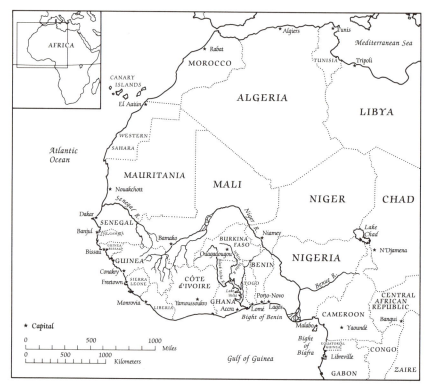

Fig. 1. Contemporary North and West Africa.

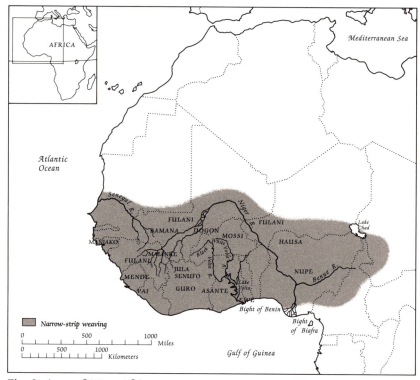

Fig. 2. Area of West African narrow-strip weaving and peoples
mentioned in the text.

10

Introduction

Perhaps more than any other art form, textiles reflect the cultures from which they come. They are simultaneously personal, societal, religious, and political, and they are valuable vehicles for the spread of ideas from one culture to another. In Africa their use and dissemination is documented for over two thousand years. African weaving is a vibrant medium that conveys the essence of an African aesthetic.

All of the cloths in this catalogue and exhibition were created by male weavers on horizontal looms that are distinguished by the narrow strips they produce. Women also weave in many parts of West Africa, but they use a broader vertical loom that produces cloth of a limited length. Unlike men, they do not use a treadle-controlled horizontal loom. Male weaving on narrow-strip, horizontal looms is geographically limited to West Africa south of the Sahara, from Senegal in the west to Cameroon in the east (fig. 2).

The West African narrow-strip loom consists of upright poles to hold the superstructure and horizontal elements to control the path of the weaving thread (fig. 3). Warp threads are fastened at one end to a bar, or breast beam, next to the weaver and at the other end to a heavy dragstone, which maintains the necessary tension on the threads so that they can be worked. It is this tensioning device, along with the narrow width of the finished cloth strip, that distinguishes the West African men's loom from other looms. The loom heddles, suspended from the superstructure, open alternate warp sheds to allow passage of the weft. On some looms the beater, which packs the woven thread tightly into the structure, also hangs from the top. In other areas, the beater floats freely on the warp threads. In many areas of West Africa, the carved elements—the pulley that controls the heddles, the cloth beam for rolling the finished cloth, the shed stick used to further open the shed, and the beater—are made by skilled carvers. These parts must be smooth so that

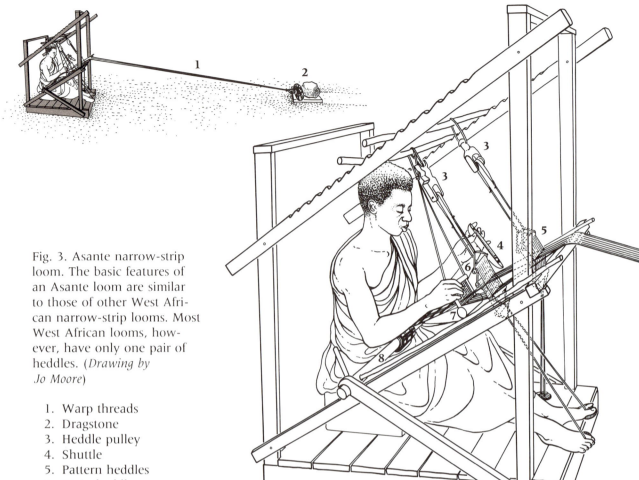

Fig. 3. Asante narrow-strip loom. The basic features of an Asante loom are similar to those of other West African narrow-strip looms. Most West African looms, however, have only one pair of heddles. (*Drawing by Jo Moore*)

1. Warp threads
2. Dragstone
3. Heddle pulley
4. Shuttle
5. Pattern heddles
6. Main heddles
7. Beater
8. Breast beam

threads will not catch on rough spots. They must also operate easily to facilitate weaving.

Throughout most of West Africa the frame of the loom is assembled by the weaver, usually from tree limbs (fig. 4). One of the basic characteristics of the men's horizontal loom is the portability of its parts. Although the importance of this characteristic may not be immediately evident to those familiar with fixed looms used inside buildings, African weavers almost always weave outside and rarely leave the loom mounted when not in use. Often weaving in their spare time, they take the loom apart and store it with the unfinished cloth until the next free moment.

The Asante weaver uses a more rigid loom structure than those employed elsewhere in West Africa. Thomas Bowdich described it in 1817:

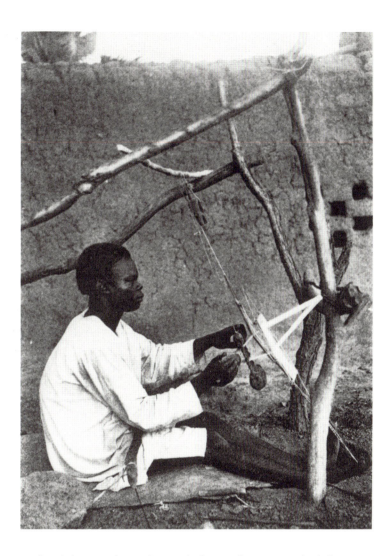

Fig. 4. Mossi weaver, Burkina Faso, c. 1900.

The Ashantee loom is precisely on the same principle as the English; it is worked by strings held between the toes; the web is never more than four inches broad. . . . The fineness, variety, brilliance, and size of their cloths would astonish, could a more costly one be exhibited. ([1819] 1966, 309—10)

The Asante loom structure may be more elaborate because most weaving is done in a permanent compound set aside for full-time weavers; the looms, therefore, do not need to be disassembled. Perhaps this sturdier form evolved to accommodate the extra heddles required to weave the complex designs used in many Asante cloths.

An interesting variation on the basic loom type is seen in Sierra Leone. The warp is fixed at both ends, and the weaver and his loom move along the warp threads (fig. 5). This method of maintaining warp tension is more directly related to the ground loom with fixed warp

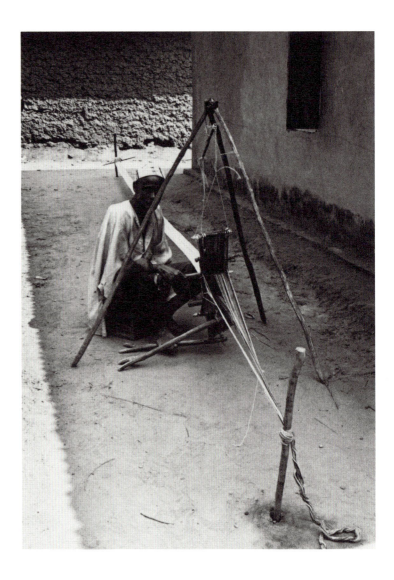

Fig. 5. Mende tripod loom, Telu, Sierra Leone, 1982. The fixed warp is related to North African ground looms, but the heddle mechanism with foot pedals is similar to other West African men's looms. (*Photograph by Alastair Lamb*)

threads used by the Berbers north of the Sahara and by some Sierra Leone weavers than it is to the dragstone loom commonly used by weavers in other regions of West Africa.

The origin of the West African men's loom is a matter of speculation because no archaeological evidence has been found to document either its development in Africa or its diffusion from another place. One type of horizontal pit loom that has some characteristics similar to those of the West African men's loom is used by cotton weavers in India, parts of Arabia, the Middle East, and East Africa. Although it produces wider cloths than West African looms, a narrower version is used for finer cotton and silk weaving. As in West African strip weaving, a method of weighting the warp independent of the loom is employed

14

(Johnson 1972, 8).[1] It is also possible that the men's loom evolved in West Africa from an ancient prototype related to today's Berber ground loom.

A precise date for the earliest presence and use of the horizontal loom in West Africa is unknown. Archaeological textiles, dating from the eleventh to the fifteenth century, have been found in caves near Bandiagara in Mali. All of the pieces from that site are composed of strips from five and one-half to ten inches wide (14 – 25 cm), leading to the conclusion that "the cotton textiles were probably woven on a loom with shafts and treadles such as is still used by the men in West Africa" (Bedaux and Bolland 1980–81, 73). Further, in 1068 the Arab chronicler al-Bakri visited the town of Silla in present-day Mauritania and described a narrow-strip loom (Johnson 1972, 11) on which was woven a "small cotton panel, which they name 'chigguya'" (Sagnia 1984, 4).

Domesticated cotton in Africa possibly has its origin in India. Archaeological evidence from the Mohenjo-Daro site in present-day Pakistan indicates that cotton was domesticated there by at least the second millennium B.C. It may have spread to Arabia and then to Nubia at the lower end of the Nile, where fragments of cotton cloth, spindle whorls, and loom weights dating from the first to the seventh century A.D. have been found (Sagnia 1984, 3).[2] From there it may have been introduced into West Africa. Archaeological excavations in Mauritania and Mali, including the site of Kumbi Saleh, the capital of the ancient empire of Ghana that reached its apogee about A.D. 1000, have revealed spindle whorls used to produce cotton thread (Lamb 1975, 75). Alternatively, it may well be that cotton was domesticated in West Africa itself before the beginning of the Christian Era (Murdock 1959, 21, 40, 70).

Thus, despite uncertainty about the origins of the men's loom and cotton, it is known that both were being used in West Africa before the tenth century. West African weavers developed a type of loom to suit their own methods of weaving and to meet the demands of their clientele. Today they continue a long tradition of creating unique and beautiful textiles.

1. Instead of being extended on the ground for some distance from the weaver, the warp on this loom is strung on various parts of the structure, and its end is weighted by a stone (Johnson 1972, 8).

2. In the Mediterranean cotton has been dated to the ninth and tenth centuries A.D., but this strain does not have the same genetic properties as West African cotton (Johnson 1972, 11).

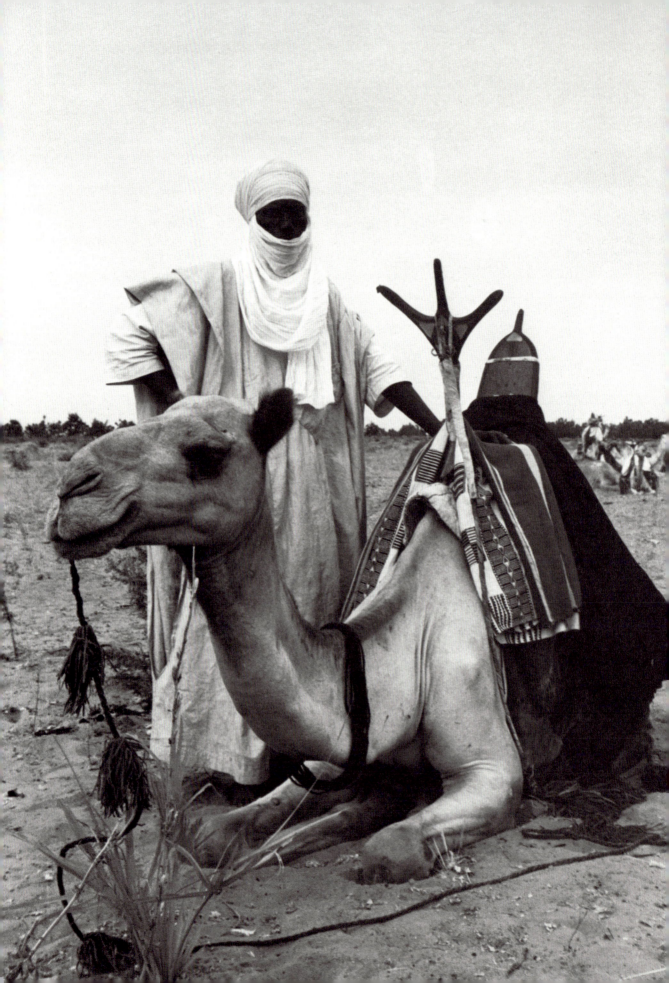

Patterns of Life

At sunrise on the appointed day the seventh ancestor Spirit spat out eighty threads of cotton; these he distributed between his upper teeth which acted as the teeth of a weaver's reed [beater]. In this way he made the uneven threads of a warp. He did the same with the lower teeth to make the even threads. By opening and shutting his jaws the Spirit caused the threads of the warp to make the movements required in weaving. His whole face took part in the work, his nose studs serving as the block, while the stud in his lower lip was the shuttle.

As the threads crossed and uncrossed, the two tips of the Spirit's forked tongue pushed the thread of the weft to and fro, and the web took shape from his mouth in the breath of the . . . Word. . . .

The words that the Spirit uttered filled all the interstices of the stuff: they were woven in the threads, and formed part and parcel of the cloth. They were the cloth, and the cloth was the Word.

—From a myth describing the origin of the world as recounted in 1946 by the Dogon elder Ogotemmêli (Griaule 1965, 27–28)

For many of the peoples of West Africa, the origins of textile production are so ancient that they are placed in the mythical past. In Dogon mythology, for example, weaving is a spiritual expression at the core of the creation of the world, the means by which order was created from formlessness. In daily African life textiles may function as wrapped garments, covers, or spatial markers. Culturally, they express the accumulated wealth and knowledge of a society and the status of their owners, and they may also have spiritual significance when used in religious ceremonies. Over much of Africa textiles were, and still are, considered prestigious items and were traded for other desirable, precious commodities.

Fig. 6. Tuareg man with his camel and saddle blanket, Niamey, Niger, 1970. (*Photograph by Eliot Elisofon*)

17

The history of West African men's weaving is closely related to the development of trade and the exchange of techniques, designs, and ideas in West Africa. The Dogon allude to such activity in creation myths describing in detail a trip the ancestors made from what is now Mali to the coastal regions of modern Ghana (Dieterlen 1972, 14–15). It is the historical movement of peoples and goods from north to south and from west to east and its impact on textiles that is explored here.

The Trans-Saharan Trade

Textile production and, most importantly, the possible exchange of fabric designs and materials in Africa can be traced to very early times. By the mid-ninth century B.C., Tyrian purple, the famed dye, was being exported widely to the Mediterranean world from the Phoenician outpost of Carthage in North Africa. So famous were the Phoenicians for creating this dye from the murex shellfish that the name of their empire, Phoenicia, was adapted from the Greek word for purple (Warmington 1969, 18). Not only did they create important dyestuffs, but by the third century B.C., a local carpet and woolen-fabric weaving industry had been developed (Ilevbare 1980, 59–60).

The establishment of trade between the northern and sub-Saharan regions of Africa also probably began very early. This activity depended not only on materials that were mutually desirable to the respective importing regions but also on the means to exchange them profitably. About 1000 B.C., either the Phoenicians from the east or the Nubians living at the source of the Nile introduced horses to the Berbers of North Africa (Mauny 1978, 278–79), and by 500 B.C. the Berbers, who probably served as middlemen in the trans-Saharan trade, were using horses and donkeys to draw chariots from Morocco south to the Senegal River, and from Carthage to the middle Niger River (Davidson 1974, 14). However the extreme costliness of such steeds probably precluded their extensive use (Mauny 1978, 280). The seafaring Phoenicians, meanwhile, explored the Atlantic coast of North Africa, where they established trading colonies by the sixth century B.C. (Law 1978, 134). The Carthaginian empire reached its peak in the fifth century B.C. when it controlled much of the western Mediterranean and the sub-Saharan trade, from which part of the empire's

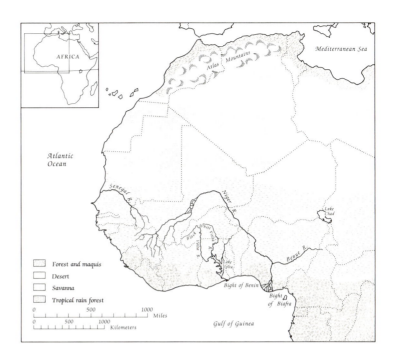

Fig. 7. Vegetation of North and West Africa.

enormous wealth was derived. Linen cloth, rugs, pottery, glassware, and other precious materials (Warmington 1981, 445–48) were carried from the Mediterranean and exchanged for dates, ivory, ostrich feathers, some slaves, and, most certainly, gold (Murdock 1959, 150). Carthage fell to the Roman Empire in 146 B.C., but the trans-Saharan trade continued to grow. Oases were established along the routes and became centers for trading activities.

The nature of trans-Saharan trade changed radically with the introduction of camels, which probably arrived in Africa in the first few centuries A.D. from southern Arabia by way of Somalia on the eastern coast of Africa and across the Sudan along long-established east-west trade routes (Curtin 1984, 21). Passage across the north-south Saharan routes took from two to three months, and the camels carrying trade goods had to be unloaded every evening (Boahen 1968, 303). These camel caravans from the north were forced to stop before they arrived at the northern edge of the forest. Because of a lack of immunity to the tropical diseases of the forest region, neither the camels nor their owners could survive. As a consequence, local traders acted as intermediaries between northern traders and producing centers to the south, using long-established trade paths through the forests (Curtin 1984, 25).

The establishment of a network of trading cities along the north-south trans-Saharan routes ultimately gave rise to the development of larger political entities. It was the desire to control the wealth associated with the trans-Saharan trade that probably stimulated the development of the great medieval empires of West Africa. The empire of Ghana, which emerged in the fifth or sixth century A.D. and lasted about one thousand years, lay astride some of the earliest and most important western routes. The routes stretched beyond the empire to a terminus in the Moroccan coastal town of Ceuta. In exchange for payments of taxes and tolls, the empire of Ghana was able to guarantee safe passage to traders. Furthermore, with the rise of a politically privileged aristocracy, new markets developed within Ghana itself. The production of surplus food made it possible for others to concentrate on non-farming activities, such as the administration of the empire and the production of luxury goods. This type of social order frequently made use of prestige clothing, as described by al-Bakri at the eleventh-century court of the king of Ghana:

> Among the people who follow the king's religion only he and his heir apparent . . . may wear sewn clothes. All other [noble] people wear robes of cotton, silk, or brocade, according to their means. (Levtzion and Hopkins 1981, 80)

Al-Bakri also described the ritual use of cloth at a chief's funeral in the empire:

> On the death of the king, they construct . . . a great dome, which they set on the place which ought to serve as a tomb; then they place the body on a couch covered with tapestries and pillows, and place it in the interior of the dome; the structure is then covered with mats and cloth; the entire assembled multitude flocks to throw earth on the tomb. (Prussin 1986, 109)

The Influence of Islam

In the seventh century A.D., Islam spread through the north of the continent following a decline of order partially caused by the fifth-century invasion of North Africa by the Vandals from Europe. By the beginning of the eighth century A.D., North African merchants controlled the trade between North Africa and the Islamic capitals of Córdoba in Spain, and Fostat (near modern Cairo), Damascus, and Baghdad in the east. One of the most important North African trade centers was Sijilmasa in southern Morocco. In the eleventh century al-Bakri commented on

the many Jewish merchants at Sijilmasa who carried tex-
tiles and other materials (Abitbol 1979, 180). They were
members of large trading families with headquarters in
Fostat (Goitien 1964, 853). Muslim traders also pen-
etrated the southern routes, and by at least the ninth
century they brought aspects of Islamic culture with them
into the markets of the Western Sudan region. It was in
this way that some areas of Africa were converted to
Islam, and it is impossible to view this conversion apart
from the development of trade. In fact, the connection
between Islam and trade goes back to the origins of the
faith, for it has been reported that Muhammad himself
was a trader (Davidson 1974, 116).

With the introduction of Islamic belief, the *hajj*, or
pilgrimage to Mecca, became an element of the cultures of
the West African empires. Wealthy West Africans may
well have started this activity in the eleventh century
(Silverman 1983, 17), yet the most famous journey was
undertaken in 1324–25 by Mansa Musa, who ruled the
Sudanic empire of Mali. Thousands of people were in his
retinue, and in Fostat and at other stops along the way he
distributed so much gold that the value of that currency
was significantly depreciated for several years after his
visit.

One of the most important aspects of these pilgrimages
was the stimulus to trade. Most of the early West African
monarchs were nominal Muslims who appreciated the
economic advantages derived from being among the
faithful, which in turn provided links to the outside
world. It is also significant that the distribution of the use
of cloth strips as currency lies along the pilgrimage route
(Johnson 1972, 8), and it may be that this ancient east-
west trade was the original dispersal path for cotton as
well as the narrow-strip loom (Johnson 1980, 201). Al-
Bakri mentions cloth being used as currency in the elev-
enth century (Johnson 1972, 2), as does Ibn Battuta
(1304–77) in 1354 and al-Maqrizi (1364–1442) before
1442 (Sagnia 1984, 6).

In the twelfth century there was unrest in the whole of
the Sudanic region due in part to the growing strength of
the Almoravids, Islamized Berbers who pushed north into
Spain and south into the empire of Ghana (Davidson
1974, 78). As a result of shifting political balances, several
new states emerged in this period. As in the past, these
political units depended for much of their wealth on im-
portant trade routes.

In the 1350s as the Moroccan traveler Ibn Battuta journeyed along one of the western routes, he described the enormous quantity of trade cloths and other goods crossing the Sahara. He documented strip weaving (Sagnia 1984, 6) and reported on the cloth he saw:

> The people of Barnu [Bornu] are Muslims, and have a king called Idris, who never shows himself to his people nor talks to them, except from behind a curtain. From this country come excellent slave girls, eunuchs, and fabrics dyed with saffron. (Hodgkin 1975, 99)

By the early fifteenth century Islamic traders were settled in Bobo-Dioulasso (in modern Burkina Faso), Bondoukou (in eastern Côte d'Ivoire), and Begho, a town situated on the northern fringes of the forest (in Ghana) (Bravmann 1974, 7).[3] Their presence was evidently due to the expanding gold trade between the producing areas of modern Ghana and the Niger River trade center of Jenne. As a result, Begho and its surrounding region became an outpost of the long-established civilization of the middle Niger River region (Wilks 1961, 5–7) and a dispersal point to the east for Sudanic weaving traditions.

European demand for West African gold grew in the fourteenth century as new coinages, expanded trade with the Far East (Wilks 1968, 313), and increased warfare left European reserves low. Thus, Europeans themselves directly entered the trade. In 1470 an enterprising Italian trader, Benedetto Dei, was doing a brisk business in coarse cloth, serge, and Lombardy fabrics in Timbuktu (Bovill 1958, 116). About 1510 the North African traveler and chronicler Leo Africanus (1459–c. 1550) described the Niger River entrepôt of Gao:

> Here are exceeding rich merchants: and hither continually resort great store of negroes which buy cloth here brought out of Barbary and Europe. . . . There is not any cloth of Europe so coarse, which will not here be sold for four ducats an ell,[4] and if it be anything fine they will give fifteen ducats for an ell: and an ell of the scarlet of Venice or of Turkey-cloth is here worth thirty ducats. (Bovill 1958, 128–29)

3. Archaeological sites in Begho have revealed a number of spindle whorls, indicating weaving activity here as early as A.D. 1350 (Bishopp 1977, 8).

4. An ell is a nonstandard measure of length that was chiefly used for cloth. The now-obsolete English ell was equal to 45 inches.

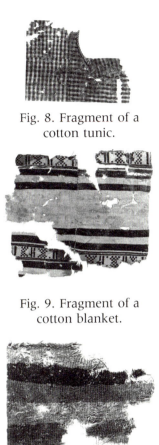

Fig. 8. Fragment of a
cotton tunic.

Fig. 9. Fragment of a
cotton blanket.

Fig. 10. Fragment of a
wool blanket.

These archaeological cloth
fragments from Bandiagara,
Mali, date from the eleventh
to the twelfth century A.D.
Figures 8 and 9 are com-
posed of narrow strips. Fig-
ure 10 is wider from selvedge
to selvedge than strip-woven
cloths, has an overall weft-
stripe composition, and con-
tains a lozenge motif. The
features of figure 10 indicate
that it is a North African cloth.
(*Photographs by G. Jansen*)

The Ancient Cloths of Bandiagara

The archaeological record shows that in the eleventh cen-
tury West African cultures were making use of trade
goods and being influenced by them. In the Bandiagara
cliffs that mark the landscape of the great inland bend of
the Niger River lived a people called Tellem by the later
inhabitants, the Dogon. In their burial caves high above
the arid plains numerous fragments of woven cotton tex-
tiles have been found. Not only are there pieces of flat
cloth, but also tunics, hats, and other garments patterned
with checks (fig. 8), stripes, and even designs using re-
peated geometric motifs (fig. 9) (Bedaux and Bolland
1980–81, 65–66). The cotton pieces are dyed indigo and
white, and some have red motifs. A few fragments have
traces of wool woven into the cotton, while others are
completely made of wool. The patterning on the wool
pieces and their larger width from selvedge to selvedge
lead to a tentative conclusion that they came from North
Africa through trade. One of the Bandiagara wool frag-
ments, for example, contains a saw-toothed selvedge de-
sign used by Berber weavers in contemporary Algeria and
Tunisia, and another wool fragment uses the lozenge mo-
tif typical of modern Moroccan Berber weaving (fig. 10).
At Bandiagara is a possible mix of indigenous woven
material and imported cloth. That such a wealth of fabric
woven on rather sophisticated looms appears at this site
implies a developed local weaving industry and a social
system structured to make use of prestige trade goods.

A tomb site, Bandiagara has yielded only burial goods,
material that was considered appropriate for the next
world as a symbol of the deceased's importance and
wealth. Thus, because of their costliness and concomitant
prestige, imported goods might be expected in addition to
locally produced textiles. The variety of materials and
patterns found would seem to support this contention.

One type of design on the Bandiagara textiles (fig. 8)
might have been influenced by checkered cotton that
was brought from India to West Africa by North African
Jewish merchants, who were specializing in the cloth
trade by the tenth century (Hirschberg 1974, 295). This
trade is described in documents from the Fostat *genizah*, a
repository for Hebrew texts (Goitien 1954, 187). The
North African cloth trade dealt mainly in dye materials
and cotton, wool, and silk threads, as well as large quan-
tities of already manufactured cloths (Hirschberg 1974,
270). Fostat was a major center in the trade between

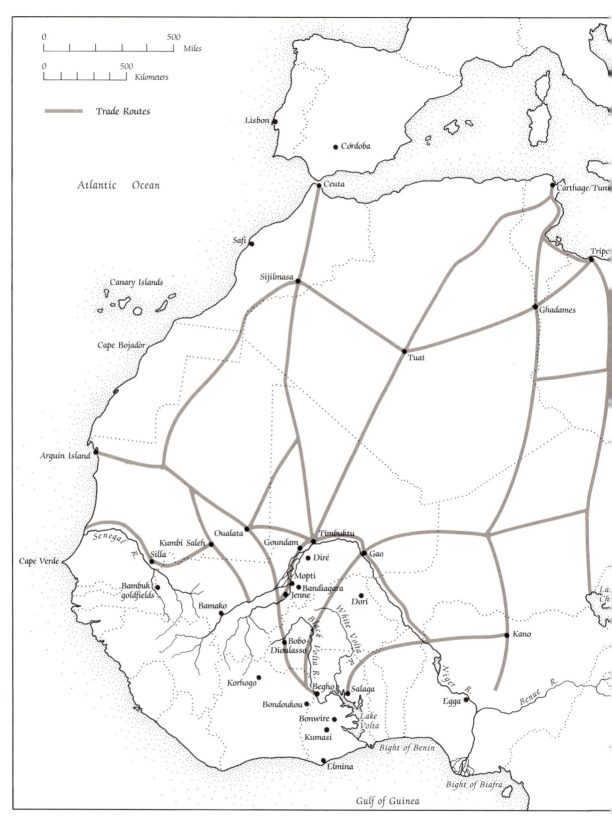

Fig. 11. Major trans-Saharan trade routes from the fourth to the eighteenth century.

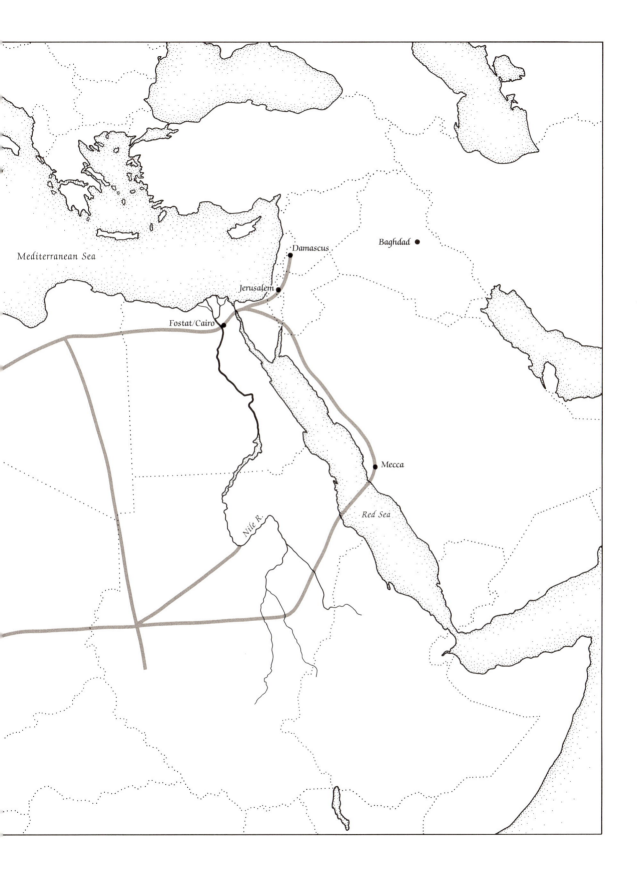

Mediterranean Sea

Damascus

Baghdad

Jerusalem

Fostat/Cairo

Nile R.

Mecca

Red Sea

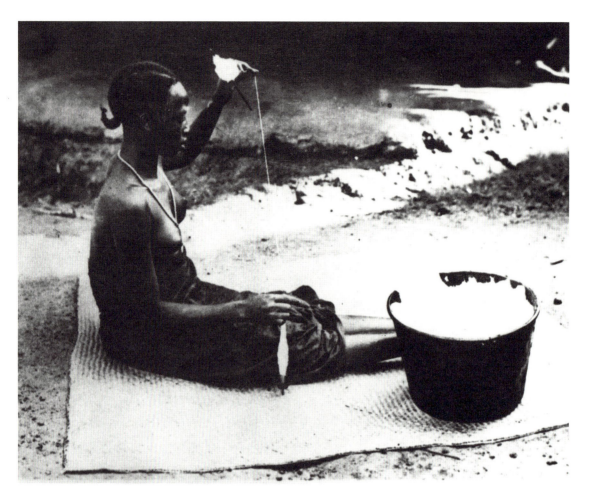

Fig. 12. Woman spinning cotton, French West Africa, early twentieth century.

North Africa and the east, and archaeological excavations there have yielded a great number of medieval Indian cottons as well as Middle Eastern fabrics. This trade was by no means one-way, for Hirschberg states that the traders also carried "[*kaasa*] and other wool apparel for which there was a demand even in India" (1974, 294). Today the term *kaasa* refers to wool textiles woven by the Fulani in Mali. It cannot be determined whether the early cloths referred to as *kaasa* by North African traders were woven in North Africa or in the Western Sudan.

Traditional Wool and Cotton Weaving

Not only were imported cloths important to West Africans, but local weaving also flourished (Niane 1984, 170). As in the past, West African wool weaving is limited to a rather small area surrounding the northern bend of the Niger River where there is enough water for sheep to

26

survive the harsh dry season and where climatic conditions require woolen materials. Among the Fulani there is a specialized caste of artisans, the *maabuube*, who have abandoned the nomadic life and settled in weaving centers. The men of this high-ranking group are weavers, and the women are potters; they are required to marry only within their group (Gardi 1985, 359). The men are believed to possess magical powers and are both feared and respected (Ardouin and Meurrillon 1985, 8). While a local legend states that weaving was introduced by a Muslim saint (Imperato 1973, 42), the whole region, from north of the desert in Berber country to the fringes of the forest, has a longstanding nomadic tradition of wool weaving that probably predates the appearance of Islam.

The large wool cloths woven in West Africa south of the Sahara are not used principally as clothing; they mainly function as furnishings within dwellings. The type of cloth known as *kaasa* was first recorded in 1150 by the traveler al-Idrisi (1100–1166), who described cloths he saw at the court of the empire of Ghana (Boser-Sarivaxévanis 1972, 131). *Kaasa*, usually made of wool, are still used today as protection from the cold during the dry season from November to January. Not only do they insulate, but due to the density of the weave, they keep out mosquitoes that breed abundantly in stagnant pools at that time of year. Nomadic people use these heavy covers on their camel saddles. They are also used to enclose the space around a bed, to cover doorways in mud-brick buildings or to block air currents and to provide shade when suspended from the edges of tents (Imperato 1979, 41).

Although woolen fabrics are generally unsuited to the humid forest conditions to the south, they are used by royalty in the Asante areas of Ghana. They may cover the palanquin of a ruler in procession, cover the state drum (Lamb 1975, 89, pls. 151 and 153), or even be displayed under the royal state swords of the Asantehene (Cole and Ross 1977, 150, pl. 12). The important functions of these imported cloths indicate their prestige.

The settled Fulani, as well as the Malinke and Jula, wove both cotton and wool cloths for a number of their neighbors who did not weave (Launay 1982, 41). Their cloths were sold to the nomadic Fulani herdsmen to wear as prestige shoulder drapes and to the Bozo fishermen of the upper Niger River as covers used in ritual ceremonies (Imperato 1979, 41). The Malinke and Jula living in Côte d'Ivoire also provided cloths for the neighboring Senufo

people to use in burial ceremonies (Launay 1982, 41). The deceased was wrapped in them, and depending on his importance, thirty or forty cloths were buried with him. Such elaborately woven cloths were symbols of wealth because they frequently took as many as five days to weave (see cat. no. 11).

Fulani- and Malinke-produced cotton cloths were sent to the forest zone to the south where they frequently were exchanged for kola nuts, a popular stimulant (Launay 1982, 14). As the local people accumulated wealth from exporting kola, they also imported prestigious trade goods, including cloth.

In 1455 the Venetian mariner Alvise da Cadamosto (1432?–1511) wrote an admittedly biased description that nonetheless does give us some insight about the garments of the inhabitants of the regions further west near the Senegal River:

> The nobles wore shirts of cotton, spun by the women. The width of the cloth was only a hands-breadth; they did not know how to make it wider, and were obliged to sew several pieces together to make it the required width. . . . The women wear nothing above the waist. Whether married or not, they had only a short petticoat reaching from the waist to the middle of the leg. (Major 1967, 260)

And in 1500 Valentim Fernandes reported from Sierra Leone:

> At home the wives of gentlemen wear a piece of cotton cloth around their posteriors and their waists that covers them to the knees, but when they go out of the house they take another piece of cloth with which they cover the body down to the feet. . . . The poor have a wrapper of wood (fibers) with which they cover the buttocks. (1951, 13, 95, translation from French by author)

Fernandes' mention of wood fibers most likely refers to the use of bark cloth for clothing, a tradition that was probably widespread in the forest region of tropical West Africa before the introduction of cotton.

In the sixteenth century both imported cloths and locally produced cotton were undoubtedly prestige goods beyond the reach of the poor, who continued to make use of other fibers and cloths. This tradition still exists in parts of West Africa such as Sierra Leone, where raffia-palm fiber cloth is made and used in the men's Poro association, whose purpose it is to maintain order in daily life, propitiate the ancestors, and educate the young. The Poro school takes place in the forest, separated from the daily life of the community. Within its confines, young boys are

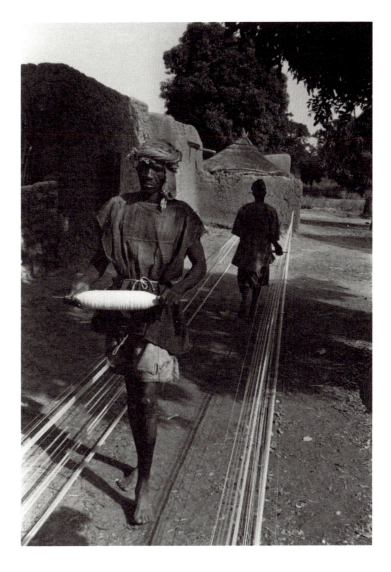

Fig. 13. Weaver laying warp
threads, Senou, Mali, 1970.
(*Photograph by Eliot Elisofon*)

taught what they need to know to become responsible
adults, such as weaving. Raffia cloth is made on a ground
loom similar to those used north of the Sahara. The con-
tinuation of raffia weaving in Sierra Leone is no doubt
due to its use by the Poro association, the guardian of
traditional life. Other Poro-associated cotton cloths were
woven in the bush to keep the uninitiated from seeing the
secret patterns in production. These were *kpokpo* hanging
cloths (cat. no. 12), used both for secret Poro rituals and
for rituals associated with chiefs (Lamb 1984, 26).

Thus, for centuries preceding the European presence on
the coast of West Africa, textile production and trade was
actively carried on. Europeans in the fifteenth century
merely reinforced ancient trading activity and introduced
more wealth into West Africa.

29

The European Coastal Trade

In the fifteenth century the Portuguese began the search for a better, more profitable way to obtain African gold and for direct access to the markets of goods from India and the East Indies. Spurred by Prince Henry the Navigator (1394–1460), the Portuguese were the first to explore and exploit systematically the resources of the West African coast. Their earliest ventures depended heavily on Italian assistance, for the Genoese had in the previous century discovered the Canary Islands and sailed along the Atlantic Saharan coast as far south as Cape Bojador in southern Morocco. In order to gain an edge, the Portuguese invented lighter and more maneuverable boats, known as caravels (Vogt 1979, 3–4). They also developed more accurate methods of charting world wind systems so that prevailing winds and currents could be matched to directions of travel (Curtin 1984, 135–36).

By 1415 Prince Henry had captured the ancient western Moroccan trading town of Ceuta, which had served since Carthaginian times as the northern terminus of the western trans-Saharan routes. Although he did not find the rich trade he had expected, his agents established friendly trading relationships with the Moroccans to purchase grains, horses, and "especially woollen textiles, which they subsequently bartered in West Africa for slaves and gold" (Hrbek 1984, 100). The goods gained during this expedition financed further exploration. In 1448 a trade factory, or warehouse, was established on Arguin Island just off the southern Moroccan coast, and by 1456 active trade was taking place in Senegal (Blake 1937, 16). In 1455 Cadamosto reported on the trade at Arguin:

> Arabs [i.e., African Muslims] come to the coast to trade for merchandise of various kinds, such as woollen cloths, cotton, silver and "alchezeli" that is cloaks, carpets, and similar articles. . . . They give in exchange slaves whom the Arabs bring from the land of the Blacks and gold dust. . . . The Arabs, likewise, take articles of Moorish silk, made in Granada and in Tunis of Barbary, silver, and other goods [to West Africa], obtaining in exchange any number of these slaves and some gold. (Latham 1964, 29)

Along with trading activities, the Portuguese also established a textile industry on the Cape Verde islands off the coast of Senegal and later on the Guinea mainland. Cotton and indigo were produced, and by the sixteenth century, slave labor from the mainland was used to establish

an important textile center where the African narrow-strip loom was modified to European production needs. The designs used on these textiles are very similar to Hispano-Moresque silks produced in the so-called Alhambra style, which emerged in thirteenth-century Spain. So highly esteemed were Cape Verde textiles that they were preferred to European textiles all along the Guinea Coast as far as Elmina, and they were even sent to Europe for sale (Rodney 1970, 72, 182). Manjako weaving in Guinea-Bissau continues these traditions, using a loom with up to thirty supplementary heddles.

In 1469 the Portuguese merchant Fernão Gomes received a five-year trade monopoly on the Guinea Coast with the stipulation that he continue explorations. The West African coast was hard to penetrate, due to prevailing winds, and at the time the area had little that Europeans desired except ivory and gold. It is likely that an indigenous oceangoing gold trade along the coast was established before Portuguese arrival, and they merely took over the operation (Wilks 1968, 314). By 1471 the Portuguese had reached the future site of their trading fort at São Jorge da Mina, known in modern Ghana as Elmina. In 1482 a fortified warehouse was constructed there to store trade goods, and residences were built for the royal governor and various workers.

Despite the large number of people living on the coast near Elmina, natural materials to make clothing were scarce. Even though there was local trade in cloth from Nigeria as well as from the Western Sudan, there was never sufficient cloth to meet demand (Vogt 1979, 67). In the early 1500s Duarte Pacheco Pereira wrote from Lagos about the Guinea Coast trade:

> Trade is carried on, principally in slaves, in cotton stuff, some leopard skins, palm-oil, and blue beads with red stripes which they call "coris"—and other things which we are accustomed to buy here for brass and copper bracelets. All these commodities have value at [Elmina]. The Factor of our prince sells them to [other] Negro traders in exchange for gold. (Hodgkin 1975, 123)

Although Pereira does not emphasize this aspect of the Elmina trade, cloth equaled 40 percent of all sales carried on there from 1480 to 1540 (Vogt 1979, 76). The most popular items traded by the Portuguese were Moroccan lambens; like contemporary hanbels, they were made to be worn poncho-style. The designs most often mentioned in trade documents had two-inch stripes of red, green, blue, and white (Vogt 1979, 67), but many other patterns

were probably also used. These patterns may have influenced West African weaving even before the beginning of the Portuguese trade, since lambens perhaps first arrived in West Africa via the early trans-Saharan trade. So important was their status to Portuguese trade that Prince John of Portugal (who became King John II in 1481) issued a law in 1480 maintaining exclusive crown rights to export lambens to Elmina. He also established Portuguese weaving factories in Safi, a town on Morocco's west coast, to produce these cloths according to trade specifications (Mota 1976, 4).

By the beginning of the sixteenth century the great empires that had created a secure passage for caravans had declined, and the focus of trade activity was shifting from the north-south Saharan routes to the West African coast. The North African terminal towns had either been captured by Christian invaders or by invaders from the Ottoman Empire in the eastern Mediterranean. It was the western trans-Saharan routes that suffered the most because of the lack of political stability. Trade continued along the eastern routes, but at a reduced level (Davidson 1974, 162–64). The increased ease and volume of coastal European trade tilted the balance of African trade from land to sea routes.

This was not an easy time for the European trading charters. There was continual jousting for favored position as one country weakened and another took over. The Portuguese were dominant from 1480 to 1530, but by the mid-sixteenth century the English were beginning to assert their trading rights. In the seventeenth and eighteenth centuries maritime trade in the Gold Coast was no longer monopolized by a single power; it was conducted by the English, the Dutch, and the Danes through forty trading forts spread along the coast.

One of the most interesting aspects of trade operations in the seventeenth and eighteenth centuries was the establishment of triangular markets. For example, European products were taken to India to exchange for cotton cloth. The cloth was then traded in Africa for gold, which was returned to Europe. In this trade triangle, probably the most important commodity for West Africans was woven and printed cotton from India, which had a ready sale due to low price and bright, nonfading colors. Not only were such cloths attractive and practical, they also found easy acceptance in the West African market, per-

haps as a result of earlier trade in Indian cloths across the overland trans-Saharan routes.

The introduction of Indian cotton cloths on the West African coast was due to the unavailability of the usual trade goods, northern European linen and North African woolens, because of political unrest in each of the manufacturing areas. From 1618 to 1621, 29,645 guinea cloths—the name derived from the Guinea Coast, a primary destination—were exported from the Coromandel Coast of southeast India for resale in Europe, Africa, and the West Indies.

The influence of European trade was enormous. New political powers emerged that prospered from trade. The establishment of ruling classes stimulated the production of luxury goods, including elaborate textiles. In addition, materials such as imported North African and Western Sudanic woolens and Indian cottons as well as European silks provided design influence to fuel the developing production of prestige cloth.

Asante and Ewe Textile Traditions

In the seventeenth century the Asantehene, the traditional ruler in the region of modern Ghana, reigned over a rather loose confederation of states, each with its own chief. The confederation was kept together by military strength and an allegiance to the Golden Stool, the ultimate symbol of the divinely inspired unity of the Asante nation (McLeod 1981, 12, 118).

The highly structured court at Kumasi required various symbols of leadership. Two of the most prestigious were gold and fine textiles (fig. 14). "A clear thing in Asante history is the way once-functional objects were elaborated and made to serve as regalia which could identify the rank and purpose of the bearer and also express ideas about political and moral relationships" (McLeod 1981, 87). As with other wealthy kingship systems, the most highly ranked persons awarded themselves the most elaborate and expensive attire. In 1614 Samuel Graham described the costume of the region: "They have a cloth over their shoulders as a cloak which is very stately in style" (Cole and Ross, 1977, 38). In Asante country, the Asantehene controlled the use and, to a limited extent, the production of such regalia. The Asantehene ordered cloths, now

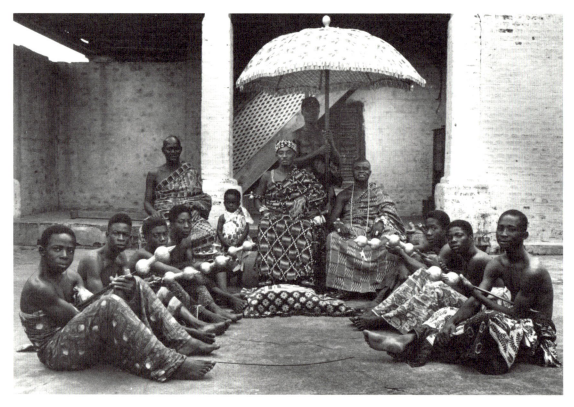

Fig. 14. Paramount Chief
Nana Akyano Akowah Dateh
II and attendant sword bear-
ers, Kumasi, Ghana, 1970.
(*Photograph by Eliot Elisofon*)

commonly known as *kente*,[5] for his household, woven in
patterns that were solely for his use. He also set aside
certain other designs for the use of favored officials or
political allies.

The origin of Asante weaving is explained in legends. A
man named Otah Kraban and his friend, Kruagu Ame-
yaw, discovered a spider weaving an intricate web while
they were out on a walk. They carefully studied the spi-
der's techniques and determined to copy its work. Upon
returning to Bonwire, which later became the royal weav-
ing town, they told their story to the chief, Nana Bobie,
who rushed them off to Kumasi to report to Osei Tutu, the
first Asantehene. The ruler was enormously impressed
and claimed this discovery as part of royal prerogative
(Bishopp 1977, 10). A different version of the legend
relates that Otah Kraban traveled to the kingdom of Gya-
man, now the Bondoukou region of Côte d'Ivoire, and
brought a loom back to Bonwire (Rattray 1927, 220). By

5. The word *kente* probably derives from the Fante word *kenten*, mean-
ing "basket" (Lamb 1975, 128). It probably came to be associated with
these cloths because they were carried in baskets from Asante country
to outside markets. Located between Asante country and the coast, the
Fante served as middlemen in the Asante-European trade.

specifying a northwestern transmission of weaving technique this version lends support to the contention that Asante cloth design was possibly influenced by earlier trade from the region of Begho and Bondoukou.

Although the original legend attributes the invention of weaving to the reign of the first Asantehene, it may have happened somewhat later while Opokuware was in power. In the 1730s the Danish factor Ludwig Rømer sent a man named Nog to the court of Opokuware, where he observed Asante weaving:

> [Opokuware] then started another kind of factory. Some of his subjects were able to spin cotton, and they wove bands of it, three fingers wide. When 12 strips . . . were sewn together it became a "Pantjes" or sash. One strip might be white, the other one blue, and sometimes there was a red one among them. . . . [Opokuware] brought silk taffeta and materials of all colors. The artist[s] unravelled them [to obtain] . . . woolen and silk threads which they mixed with their cotton and got many colors. (Bishopp 1977, 11)

The Asante further developed *kente* traditions by exploiting the rich materials available to them through trade. The expansion of design possibilities afforded by new materials matched the wealth the nation was accumulating because it controlled trade with Europeans on the coast. By the end of the eighteenth century Asante power extended over 150 miles east to west and 90 miles north to south.

While North African woolens, Indian cottons, and northern European linens were the most in demand in earlier coastal trade, in the eighteenth century silk fabric and thread became increasingly important. Early trade in silk was centered in the important northern Nigerian market town of Kano, which obtained the lustrous thread from trans-Saharan trade and widely distributed it both south to the Yoruba and southwest to Asante country. Another source for silk was the town of Egga in Nupeland in northern Nigeria, where the cocoons of wild moths were gathered and silk threads spun from their inner wrappings. And from the north came "unwrought silk of a red colour, which they . . . weave in stripes into the finest cotton tobes [robes]," according to British explorer Hugh Clapperton in 1826. Heinrich Barth, who traveled in the region from 1851 to 1854, also reported that this type of silk was the principal merchandise carried from the North African trade city of Ghadames into Kano (Johnson 1973, 356–58). In fact, it was waste silk left

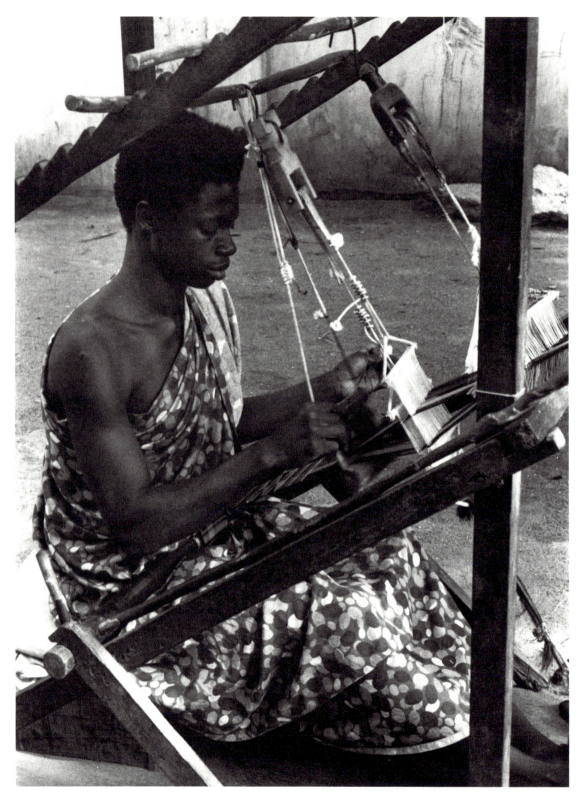

Fig. 15. Asante man weaving *kente* cloth, Kumasi, Ghana, 1971. Two pairs of heddles are often used to construct the ground weave and the decorative patterns. (*Photograph by Eliot Elisofon*)

over from French and Italian silk processing mills that was sent to North Africa, where it was dyed in colors not readily available to the south, especially magenta (Johnson 1983, 131) (cat. no. 16).[6] Not only was unwoven red silk imported, but silk was also obtained by unraveling already manufactured imported goods. As Nog reported, this was already being practiced by the rule of Opokuware in the 1730s. In 1817 Bowdich commented on unraveling imported silks. In addition, he reported on another source for hard-to-obtain red thread: "A highly glazed British cotton of bright red stripes with a bar of white: it is bought solely for the red stripe, . . . which they weave into their own cloths, throwing away the white" (Bowdich [1819] 1966, 332).

Imported silk was available to a limited number of weavers; most weavers used cotton thread produced in the northern town of Salaga, which was strategically located near the ancient trade routes. Here, as in virtually all of West Africa, cotton spinning was women's work, and in many areas women also grew the crop and made it into thread. Cotton cloth remained important in Asante country well into the twentieth century.

Imported silk led to the development of prestige silk garments associated with and controlled by the court at Kumasi. Bowdich described the brilliant display made by these garments: "The caboceers [chiefs], as did their superior captains and attendants, wore Ashantee cloths, of extravagant price from the costly foreign silks which had been unravelled to weave them in all the varieties of colour, as well as pattern; they were of incredible size and weight, and thrown over the shoulder exactly like the Roman toga." Bowdich noted that the chiefs wore delicately wrought leather sandals with these elegant garments and were covered with a great variety of gold ornaments so heavy that their arms had to be supported by small boys ([1819] 1966, 35).

During a visit to Kumasi in 1825 Joseph Dupuis observed an important ceremony, *awukudae,* during which the Asantehene ritually provided food to the blackened stools believed to house ancestral spirits in order to ensure the well-being of the Asante nation. For this ceremony, the Asantehene was ritually garbed: "A large white cotton cloth which partly covered his left shoulder, was

6. *Waste silk* refers to the loose filaments at the core of the cocoon that remain after the single filament has been unreeled (Goitien 1961, 177).

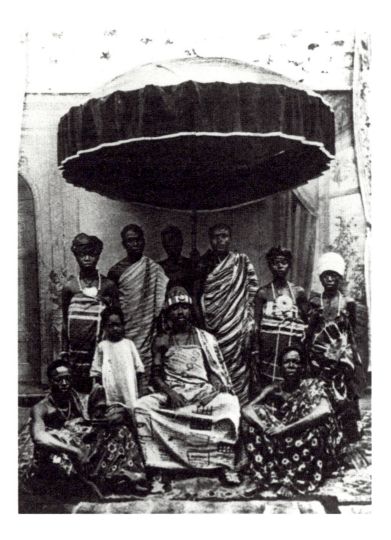

Fig. 16. Asante chief, Ghana, early twentieth century. The chief (*seated in center*) is wearing a wrapper covered with Islamic inscriptions.

studded all over with Arabic writing in various coloured inks, and of a most brilliant well-formed character'' (fig. 16). Such a garment's inscriptions of Islamic prayers and Allah's name further empowered the Asantehene (Bravmann 1986, 5).

Cloths could also be used as an indirect reference to the Asantehene's power. Bowdich described some officials who were lavishly equipped by the king as they set out on official business to another town. The king ''enriches the splendour of his suite and attire as much as possible; sometimes provides it entirely; but it is all surrendered on the return . . . and forms a sort of public state wardrobe'' ([1819] 1966, 294).

The power of the ruler also extended to important spirit shrines. In Bono country north of Kumasi, *kente* cloths are still used to dress altars for spirits. The final arrangement of the cloth is intended to recall the image of a seated chief

38

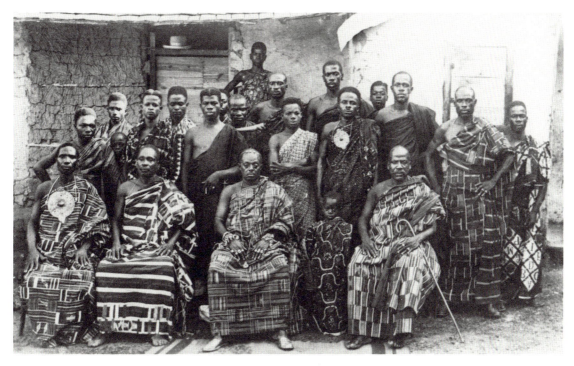

Fig. 17. S.M. Boa Kouassi, king of the Anyi Ndenye (*seated third from left*), and village notables, Côte d'Ivoire, early twentieth century.

and, by association, the prestige of the spirit. A chief's regalia is sent to the altar of a spirit that had given him aid, or, if those responsible for the shrine are wealthy enough, they purchase its finery (Silverman 1986).

Generally, a man's cloth is wrapped around the body, passed over the left shoulder and brought around the body again. The cloth must always be worn properly so that the woven stripes are straight horizontally and vertically, or the status of the wearer is diminished (Bishopp 1977, 33) (fig. 17). The left shoulder and arm are usually covered because they are considered unseemly and dirty (McLeod 1981, 145). If an incumbent officeholder goes to the room where the blackened ancestral stools containing the souls of deceased ancestors are kept, he allows his cloth to slip off his left shoulder to bare his chest as a sign of respect (McLeod 1981, 117). He might even wear an old cloth to represent his humble status in relation to the spirits or the state (McLeod 1981, 143).

The everyday arrangement of a wrapper has developed into a high art of gesture. Cole and Ross describe this as a "dance of adjustment," encompassing expansive wrapping and unwrapping gestures (1977, 16). Wrapped garments create a kind of aesthetic space surrounding the body; it extends as the wearer moves and contracts as he assumes a static pose. This space enhances the body's

potential for graceful movement, the ultimate expression of which occurs during dance or ritualized activity.

Most royal weaving was done in Bonwire. When the Asantehene needed new cloths, they were ordered from one of the Bonwire weaving groups. In traditional times the Asantehene commissioned new designs and used them strictly for himself. He also had the right to designate other designs for the sole use of high officials.

Weaving in Bonwire was done only by order directly between the purchaser and the weaver. Partial payment was sometimes made before weaving began to help defray the costs of materials, but it was not completed until the order was finished to the customer's satisfaction. Although Bonwire was the center of royal weaving, *kente* cloths were also made in other weaving towns, such as Salaga in the north, perhaps because the weavers were closer to the supply of cotton and wanted to remain free of the court's controlling regulations (McLeod 1981, 156). When weaving for a chief outside the royal court, the weaver sometimes lived in the chief's compound, where he was fed and housed for the time it took to make a cloth (McLeod 1981, 179).

Bonwire today remains an important weaving center. While it is common in West Africa for the craft of weaving to pass from father to son or from uncle to nephew, in Bonwire apprentices come from throughout the region to study with known masters. As with any system of learning, apprentices are given easy tasks, such as winding the warp or preparing shuttles. As they grow more experienced, the master introduces them to laying the warp on the loom in the numerous traditional patterns. There is often a small fee attached to apprenticeship because the master weaver is expected to house and feed his charges. Any cloths the apprentices produce are the master's to sell. Virtually all weaving done at Bonwire workshops is now commissioned by private customers. The largest obstacle to establishing oneself as an independent weaver is acquiring enough capital to purchase the raw materials to make cloth. Near the end of service to his master, an experienced apprentice can sell his services to other workshops to obtain cash. When he has enough money, he establishes himself in his own workshop and is then considered to be in the proper position to marry.

The Ewe people, neighbors of the Asante in far southeast Ghana and western Togo, also weave cotton cloths. According to oral traditions, the Ewe moved to their pres-

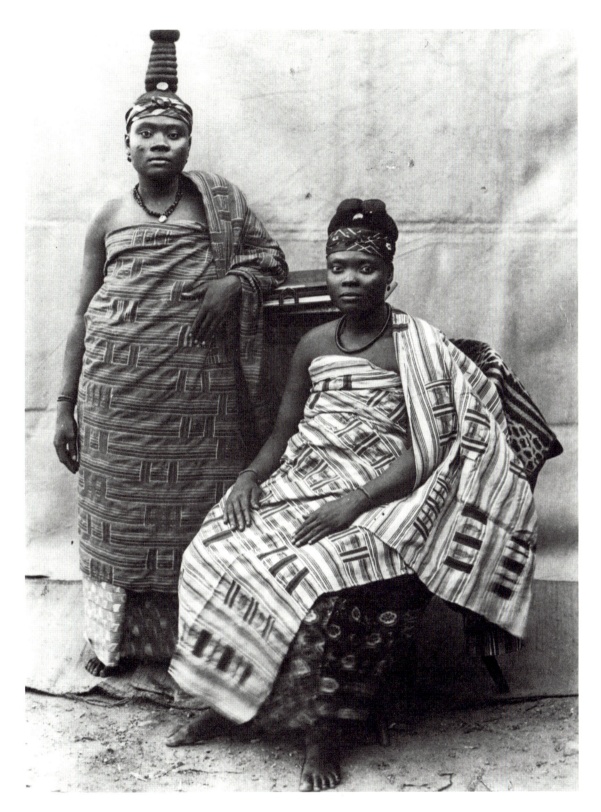

Fig. 18. Asante women wearing elaborate cotton
wrappers, Accra, Ghana, early twentieth century.

ent location from east of the Niger River sometime before the seventeenth century. They were outside the region of active trade and had few visitors. By the third quarter of the eighteenth century the Ewe were under the control of the powerful Asante, and in the mid-nineteenth century Asante domination was nearly complete (Bishopp 1977, 12–15). In 1785 Paul Isert, a merchant, mentioned an Ewe loom that looked like the Asante type and produced narrow strips (Lamb 1975, 95).

Although Ewe cloths are similar to Asante cloths, there are some important differences in patterning and the social context in which they are made. Historically, the Ewe did not have a strong centralized government; as a result, cloths were not royally commissioned. Further, there also was no royal domination of design, and as a consequence, the creative impetus for pattern development came from the weaver and the marketplace.

The absence of royal patronage is evident in the use of Ewe textiles. While sumptuous cloths are usually worn for festivals and on important religious holidays, the cloths also mark rites of passage, times in a person's life when a new stage is entered. Special cloths are commissioned when a girl reaches puberty, or when she is married, or if she has just borne a child. Chiefs who sit in judgment or who have secured a political victory also order special cloths (Bishopp 1977, 34–36).

In addition to their association with special occasions, cloths are related to the wisdom of proverbs, which are visually realized through the use of specific motifs in intricate weft-float patterns. The meaning of the proverbs is concerned more with the necessities of daily life than with prestige. A pattern of a hand, for instance, refers to the maxim "It is with the hand we work" (cat. no. 34, detail). A locket denotes "One must be wealthy to wear a gold locket" or "One must have means for any undertaking." Crossed lines, which may be interpreted to symbolize a scarification pattern or a rudimentary signature, may express the proverb "Every man must carry his own mark," signifying that a person is known for his own personality (Bishopp 1977, 42–43).

Throughout West Africa, weavers have adapted foreign elements to suit their own needs, creating unique motifs to express cultural values. The history of textile trade the world over is full of such examples of adaptability and adjustment that enrich the total cultural sphere.

Composition in West African Strip Weaving

Designs are created in West African strip weaving by introducing colored threads in the warps to make warp stripes and in the weft to create weft stripes, as well as by adding supplementary threads in areas where other patterns are desired. Different methods of combining these elements lead to distinct weaving styles.

Wool weaving is perhaps the most ancient weaving in West Africa, and the patterns associated with wool cloths resemble those of sub-Saharan West African archaeological examples and North African examples. Textiles from these areas are mainly decorated with weft stripes that, in the case of narrow-strip weaving, may be lined up from one strip to the next to create a continuous band across the cloth.

In North Africa Berber women weave wool cloths on a wide loom, and the geometric designs they produce are oriented in bands along the weft (fig. 19). In Mali, however, men weave wool cloths on narrow-strip looms. Even though it is technically more difficult, motifs like those used in North Africa are lined up weftwise after the strips are sewn together. This type of design organization is difficult to produce in narrow strips because the weaver must accurately calculate the distance between motifs on each strip so that they will match after the cloth is sewn together. Malian weavers may have originally reproduced characteristics of North African trade cloths because the cloths were so popular in West Africa. Although the technique of weft-dominant patterning was used, the broader loom was not; rather, the designs were altered to fit the narrow-strip technology of West Africa.

The archaeological textiles found at the Bandiagara site in Mali further reinforce the evidence for the history of this mode of composition. These cloths are mainly patterned with alternating stripes aligned across the weft (fig. 9). Where supplementary weft patterns occur, they are worked into the striped design. One of the Bandiagara motifs, the so-called hourglass, can be found on contemporary textiles (cat. no. 19) as well as on a robe collected on the Benin coast of Nigeria before 1659 by the German merchant Christoph Weickmann (Lamb 1957, 86–87). The contemporary use of these designs and their

43

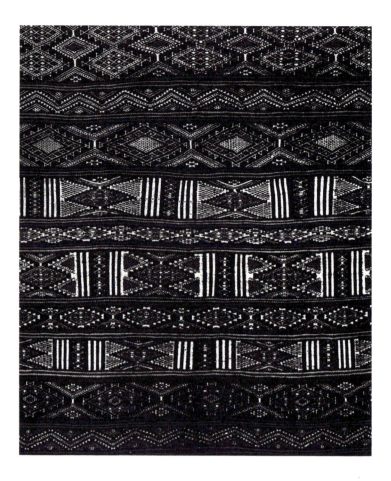

Fig. 19. Detail of a woman's wrapper, Kabyl people, Tunisia, c. 1920. The motifs on this cloth are typical of North African textile design. Martha Delzell Fund, Indianapolis Museum of Art, 1984.209. (*Photograph by Melville McLean*)

weft orientation demonstrates the resilience of traditional aesthetic canons.

One of the two North African-inspired designs illustrated in this catalogue is a lozenge design, created by the insertion of a supplementary weft thread. It may be related to the North African "evil eye" pattern, which protects against the harmful glance so dreaded by Muslims (cat. nos. 3, 8, 9, 11). Specially empowered individuals are believed to use this force for evil; wearing the image of an eye is thought to cast it off (Gilfoy 1983, 210). The second design, an abstracted hand, may represent the hand of Fatima, Muhammad's daughter, which is thought to be equally empowered to drive off evil (cat. no. 12). Even though many people using such textiles in sub-Saharan West Africa are only nominal Muslims, as are the Berbers of North Africa who also use these motifs, a number of Islamic protective devices are considered to be magical helpers.

While textiles made of wool use weft-dominant patterning, those made of cotton most frequently carry warp

patterns, although most West African strip-woven cotton is left unpatterned in white or dyed a solid color such as indigo. Solid-color cloths have been used as garments and household textiles by ordinary people for hundreds of years. The simplest form of ornament on cotton cloths consists of warp striping, usually in indigo and white (cat. nos. 14 and 15). The Dutchman Pieter de Marees, who was in the Guinea Coast region about 1600, reported: "Their Governours (as Captains and Gentlemen) are better apparelled than the common sort of people, and are as well known by their garments to be such. They go in a long cotton garment close about them like a woman's smocke full of blue stripes, like feather bed tikes" (Bishopp 1977, 5). Even though warp stripes predominate in cotton weaving, some cotton cloths woven in Sierra Leone are so heavily influenced by Malian woolen models that they also carry weft stripes with typical northern design elements worked into them (cat. nos. 1 and 2). Undoubtedly, these cloths were woven of cotton because of the hot, humid climate in the coastal forest regions.

The checkerboard is another basic West African design. This pattern can easily be achieved in strip weaving by alternating dark and light areas of the weft in neighboring strips (cat. nos. 8, 9, and 10). The Dogon people of Mali, who presently occupy the Bandiagara region, perceive rectangularity as giving structure to the unformed words of the spirits. In both their daily life and in ritual regalia, the checkerboard motif predominates. Dogon fields are plowed in crisscrossed rectangles, and rectangles also appear on ritual masks and as shadow-and-light motifs on buildings (fig. 20). In other areas of West Africa the geometric alternation of dark and light is present on masks, in architecture, and on objects of daily use. This design element expresses the oppositions and contrasts found in life on earth as well as in the spiritual realm, for example, male-female, wild nature-settled community, day-night, and lack of control-structure.

The checkerboard design may also be related to the magic squares of Islamic belief. Muslims, as do some other peoples of the world, symbolize the orderly cosmos as an arrangement of squares emanating from a central point. In Islamic thought this center is devoted to Allah and all points issuing in any direction are numerically equivalent to each other (Prussin 1986, 75). The combination of this philosophy with what may be an earlier predilection for geometric patterning is reinforcement for the use of such designs as magical protection. The composition of cat-

alogue numbers 11 and 12, with their emphasis on the center of the cloth, illustrates another aspect of this concept. Other Islamic designs, such as the lozenge (cat. no. 11) and a variation on the hand of Fatima (cat. no. 12), are also used to surround the spiritual center.

While checkerboard symmetry is certainly important to a number of cloths in West Africa, it is by no means a dominant design. Another principle that might appear to be the random placement of design elements is in fact a well-planned aesthetic system. In African music a strictly regular pulse is frequently only implied while a wide range of rhythmic variations embellish the basic structure. In African textiles this principle of rhythmic variation can be seen in the carefully matched end borders and the varied placement of design elements in the central field of catalogue number 19. The technique of weaving narrow strips and later assembling them lends itself to this type of design, which would be difficult and time consuming to produce on a broadloom. The Western patterning loom, developed from the ancient Chinese drawloom, cannot efficiently achieve such design variations. The patterning device it uses depends on a regular repeat, either exactly imitated or reproduced in mirror form.

It is important to credit the influence of the type of equipment used in West African weaving on textile design. Perhaps one of the reasons narrow-strip looms originally developed and continue to be used today is that they can produce nonsymmetrically designed cloths. The final composition is not a case of happenstance, but it is rather a carefully orchestrated rhythmic placement of design elements.

The combination of all of these elements characterizes the design of Asante *kente* cloths. Certainly the earliest cloths woven for the Asante court were made of cotton, and the most basic type of cloth ornamentation in the Guinea Coast, as well as in large areas of Western Africa, is blue-and-white warp striping. The original impetus to use stripes in Asante weaving probably came from cloths imported from the Bondoukou area to the northwest at the beginning of the sixteenth century (McLeod 1981, 155). There was undoubtedly pattern development, progressing from simple warp striping to the addition of weft bands and culminating in the nineteenth century with the use of multicolored fibers, including silk (Bishopp 1977, 18–20). It is also probable that at first rectangular weft blocks were used in nonsymmetrical placement and then

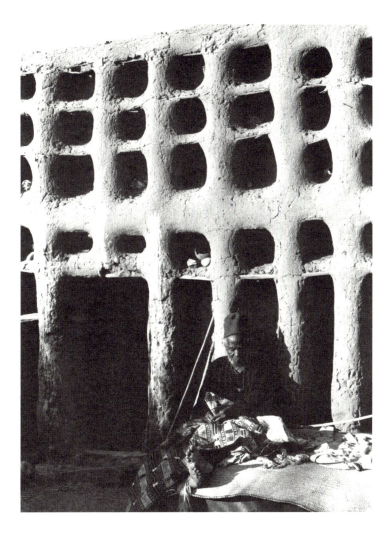

Fig. 20. House of a lineage head, Dogon, Sanga region, Mali, 1970. (*Photograph by Eliot Elisofon*)

blocks with more complex weft stripes evolved, finally culminating in the rigorous, richly developed designs that are typical of most of the silk and rayon cloths seen here (Cole and Ross 1977, 39–40).[7]

Not only is composition ordered, but there is a hierarchy of designs from the simplest warp stripes, called *ahwepan* (Bishopp 1977, 21), to the most complex, and hence most costly, weft designs used by the court. Some of the latter cloths are called *adweneasa*, which means "my skill is exhausted" (Rattray 1927, 237). In order to create complex weft designs the weaver employs a third pair of heddles and also introduces patterns that do not extend from selvedge to selvedge. This is a slow and tedi-

7. Rayon began to be widely used during World War II. In Africa it is used as an inexpensive substitute for silk.

47

ous process and demands great skill; as a result, these cloths are expensive and the most important of prestige garments.

Many motifs have a specific name that becomes the name of a cloth. The process of assigning meaning to everyday objects is common among the Asante, for arts and crafts are used as a medium for the expression of the deepest philosophical and religious thought: "an intelligent person is admonished in proverbs not in pedestrian language" (Anquandah 1982, 108). Rattray (1927) recorded over three hundred pattern-associated proverbs in the 1920s. The supplementary weft designs often have names that refer to inanimate objects, animals or birds, plants or trees, or important individuals, usually rulers. Other designs are associated with historic persons or events (McLeod 1981, 155–56).

Color symbolism is also important in Asante cloths. Bowdich recorded information on the materials the Asante used to obtain dyes: "They have two dye woods, a red and a yellow; . . . they make a green by mixing the latter with their blue dye, in which they excel; it is made from a plant called acassie, certainly not the indigo, which grows plentifully on the Coast" ([1819] 1966, 310). Light-colored cloths such as white, yellow-gold, and cream are considered to be of good omen, associated with innocence and joy. White cloths that sometimes contain a little blue are worn by chiefs when making sacrifices to the ancestral stools to encourage the ancestors' assistance. They might also be worn by ordinary people to celebrate the success of a law case or by parents taking their newborn child for its first outing (McLeod 1981, 149). Red colors are related to blood and life forces, and black, blue, and indigo represent death and darkness (Hagen 1970, 8–14).

The rich traditions of *kente* weaving are part of a centuries-long pattern of textile production and exchange in West Africa. As outside influences entered West African cultural spheres, new textiles were produced that retained aspects of traditional designs but incorporated new aesthetic elements. The warp-striped, checkerboard, and intricate geometric compositions produced on West African narrow-strip looms reflect the vibrancy, the aesthetic receptivity, and the creative genius that has marked West African textile history.

Catalogue of the Exhibition

The first group of textiles in the exhibition, catalogue numbers 1–7, is characterized by weft-stripe designs that run the width of the cloth. This type of composition is typical of Western Sudanic weaving, particularly weaving by the Fulani, and it may have been influenced by North African cloths. The composition of the second group of textiles, catalogue numbers 8–13, is marked by a checkerboard arrangement of dark and light squares in addition to the stripes found in the first group. The blue-and-white cloths of the third group, catalogue numbers 14–25, were woven by the Asante of Ghana and illustrate the combination of the design elements found in the first two groups. The final group, catalogue numbers 26–36, comprises magnificently colored Asante *kente* cloths and Ewe cloths.

The information listed in the catalogue entries begins with the description of the textile. Next, the identification of the people who wove the cloth and the name of the contemporary nation in which they now live is given. For the most part, these attributions were made by Renée Boser-Sarivaxévanis, who worked with this collection in 1985 and 1986 during her Smithsonian Regents Fellowship. A brief analysis of technique follows. The measurements are then given in inches and in centimeters, beginning with the warp, or lengthwise, measurement. Finally, accession data and, when available, field collection data are given.

More detailed technical information is as follows: first, materials used; second, techniques; and third, publication information. Technical terms are derived for the most part from Irene Emery's *The Primary Structures of Fabrics* (Washington, D.C.: Textile Museum, 1980), and the reader is referred to that seminal volume. The materials section identifies the types of yarn used and their colors. Identification of the fibers, which was carried out by textile conservator Cara Varnell, is limited to selected yarns. The section dealing with techniques outlines in detail the various characteristics of the cloth.

1
Furnishing fabric
Fulani people,
Niger Bend region, Mali

Cotton plain weave with cotton
 supplementary weft
101½ x 63 in. (257.8 x 160 cm)
Purchased with funds provided
 by the Smithsonian Institution
 Collection Acquisition
 Program, 1983–85
Lamb 145 M
Purchased in Mali in 1971

Materials
Ground warp: cotton machine-
 spun S-twist, white
Ground weft: cotton machine-
 spun S-twist, dark blue;
 cotton machine-spun Z-twist,
 white
Supplementary weft: cotton
 machine-spun S-twist, dark
 blue

Techniques
Weft-faced plain weave with
 continuous supplementary
 weft
Proportions: 2 warps to 1 weft
Thread count: warp pairs, 12
 per in. (5 per cm); weft
 57–85 per in. (22–34 per cm)
Supplementary weft bundles of
 6 pass over and under 2, 4, 6,
 and 8 warps

Six panels handsewn at
 selvedges; selvedge to selvedge
 width 10⅜ in. (26.4 cm)
Fringe: 4 warp pairs Z-ply;
 length 2½–3 in. (6.4–7.6 cm)

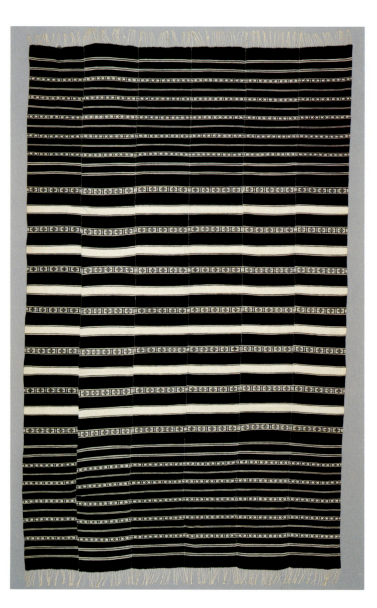

The patterns on this piece and their placement in weft stripes
indicate a weaving vocabulary that can be traced to both
North Africa and the Sudanic archaeological site of
Bandiagara. At the ends of the cloth, the stripes are narrower
and more densely arranged than in the central field. The weft
stripes, common in West African cloths, are similar to those
found in the end bands of Asante and Ewe cloths (cat. nos.
23, 30, 32, 33, and 34). Cloths of this type are also popular
along the Guinea Coast (cat. no. 2).

 Renée Boser-Sarivaxévanis notes that the dark indigo color
in this piece is characteristic of cloths produced by the Fulani
in the Niger Bend region. The collectors, Alastair and Venice
Lamb, believe that it was woven by the Bamana people in
the Bamako area of Mali.

2
Wrapper
Possibly Mende people, Sierra Leone

Cotton plain weave with cotton
 supplementary weft
52⅜ x 51½ in. (133 x 130.8 cm)
Purchased with funds provided
 by the Smithsonian Institution
 Collection Acquisition
 Program, 1983–85
Lamb 823 SL
Collected in Sefadu, Sierra
 Leone, in 1934

Materials
Ground warp: cotton handspun
 and machine-spun Z-twist,
 dark blue
Ground weft: cotton handspun
 Z-twist, dark blue, white
Supplementary weft: cotton
 handspun Z-twist, dark blue

Techniques
Weft-faced plain weave with
 continuous supplementary
 weft
Proportions: 2 warps to 1 weft
Thread count: warp pairs, 12
 per in. (5 per cm); weft 37
 per in. (15 per cm)
Supplementary weft pairs pass
 over and under 2 and 4
 warps, and over 2 under 6
 warps
Ten panels handsewn at
 selvedges; selvedge to selvedge
 width 5 in. (12.7 cm)
Fringe: warp pairs unworked;
 bottom length 1⅝–3⅞ in.
 (4.1–9.8 cm) and top length
 ⅜–1 in. (1–2.5 cm)

Published
Venice and Alastair Lamb, *Sierra
 Leone Weaving* (Hertingford-
 bury, England: Roxford Books,
 1984), 114, fig. 121.

The pattern and composition of this modest cloth are related to catalogue number 1. Such similarities in style make it difficult to determine where a particular cloth was woven. Commonly used in trade, many of the cloths are woven further inland for sale in Sierra Leone and Liberia. Further, the Lambs suggest that this piece, collected in Sefadu, Sierra Leone, may have been woven in Guinea.

These cloths were often used as currency. Their durability, ease of storage, and high demand made them prestige items. In Mende country, "a man's wealth not only consisted of his dependents (wives and slaves), but also the number of his country cloths" (Fyle and Abraham 1976, 107–8).

This cloth is probably a woman's wrapper. The wives of a Gio chief in southeastern Liberia have been illustrated wearing similar cloths (Schwab 1947, fig. 43b). The women wore them with "the ends deftly hitched up by rolling the entire upper edge of the cloth outward" (Schwab 1947, 109).

3
Wrapper or furnishing fabric
Fulani people, Mali

Cotton and wool plain weave
 with cotton and wool inserted
 weft
104¼ x 54½ in. (264.8 x 138.4 cm)
National Museum of Natural
 History, 341656
Collected in Timbuktu, Mali,
 before 1928 by C. C. Roberts

Materials
Ground warp: cotton handspun
 Z-twist, white
Ground weft: cotton handspun
 Z-twist, white; wool
 handspun Z-twist, dark
 brown, tan, white
Inserted weft: cotton handspun
 S-twist, white; wool
 handspun Z-twist, tan, brown,
 dark brown

Techniques
Weft-faced plain weave with
 inserted weft
Proportions: 2 warps to 1 weft;
 six warp bundles at each
 selvedge
Thread count: warp pairs 12 per
 in. (5 per cm); weft 90 per in.
 (35 per cm)
Five panels handsewn at
 selvedges; selvedge to selvedge
 width 10¾ in. (27.3 cm)
Fringe: warp pairs braided across
 ends of cloth to form braided
 tassels, 3 at each seam and 3 in
 center of each panel; length
 4–10¼ in. (10.2–26 cm)

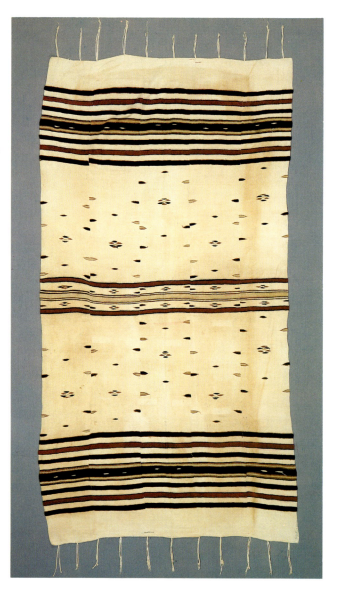

Woven cotton covers such as this one are known as
munnyure. Highly prized for their softness, they are primarily
used as sleeping wrappers, but they also may be worn.

In this cloth, regularly placed stripes at the top and bottom
enclose a field of asymmetrically placed elements. The
lozenge-shaped units were formed by inserting
supplementary weft threads that deflect the ground weft. The
selvedges are sewn in a distinctive manner. The sewer's
needle caught seven weft threads on each side as he made
running stitches. Strips are usually joined with overcast
stitches. Boser-Sarivaxévanis attributes this piece to the Upper
Niger River Delta or to a Fulani settlement in Burkina Faso,
such as Dori.

4
Furnishing fabric
Fulani people,
Mali or Burkina Faso

Wool plain weave with cotton inserted weft and wool supplementary weft
98¼ x 46⅝ in. (249.5 x 118.5 cm)
National Museum of Natural History, 341658
Collected near Kano, Nigeria, before 1928 by C. C. Roberts

Materials
Ground warp: wool handspun Z-twist, white
Ground weft: wool handspun Z-twist, white, brown, dark brown, black
Supplementary weft: wool handspun Z-twist, dark yellow, black, brown
Inserted weft: cotton handspun S-twist, white; wool handspun Z-twist, dark brown, red-brown, yellow
Braid: wool machine-spun, black

Techniques
Weft-faced plain weave with discontinuous supplementary weft
Proportions: 1 warp to 1 weft (bundles of 6 warps at selvedge edges)
Thread count: warp 12 per in. (5 per cm); weft 75 per in. (30 per cm)
Supplementary weft passes over and under 2–12 warps
Six panels handsewn at selvedges (except for red-brown bands at lower edge); selvedge to selvedge width 7⅞ in. (20 cm)
Braid sewn over outer edges and down center seam
Fringe: warp ends braided across end of cloth to form braided tassels (3 at each seam); length 4½–6 in. (11.4–15.2 cm)

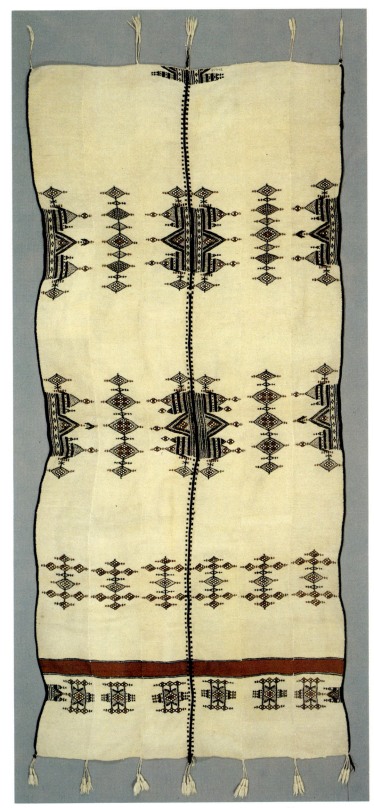

Text on next page.

53

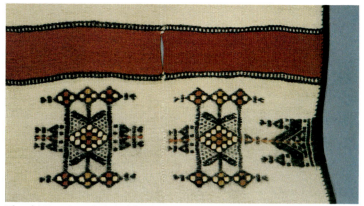

The *bitjirgal* and *dakol boderi* patterns.

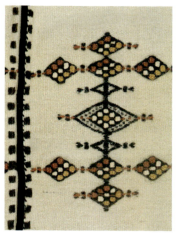

The *bidal* pattern.

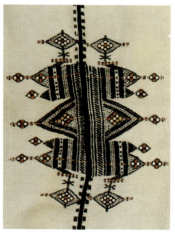

The *landal* pattern.

Wide distribution of wool *kaasa* through trade has led the weaving to be attributed to a variety of locations. These valued cloths have been found in the great Nigerian market town of Kano and in Ghana among the royal accessories of the Asante ruler. Because a large number are sold at the market in Mopti, Mali, they are often called "Mopti blankets." Boser-Sarivaxévanis believes that this cloth was made in the town of Dori in Burkina Faso, the home of many Fulani weavers who migrated from the Niger Bend region.

The designs on a *kaasa* form a corpus of meaning. The pattern at the lower end of this cloth, the first woven, is called *bitjirgal*, "a water recipient," said to symbolize water thrown from a container to the ground. It is also referred to as the "mother of the *kaasa*," a symbol of maternity and fertility. The design represents the sexual organs of a woman (central spotted diamond) and her shoulders, hands, and feet (smaller diamonds and connecting lines). The next design, a broad stripe, is called *dakol boderi*. It illustrates the mouth (red stripe) and the gums and teeth (black lines and white dots) of the woman. The pattern above the stripe is called *bidal*. It represents the family compound or, in some areas, trees with ripe and unripe fruit.

The central design, called *landal*, is the largest and most impressive. The straight black lines portray the routes taken with the herds to find food. The large pointed shapes represent hillocks where dwellings are built to protect them from annual floods. These designs are also strikingly similar to Islamic architectural motifs. The diamonds at the top and bottom represent the two sons of the woman in the *bitjirgal* design, who were separated as infants. The brothers chanced to meet on a path later in life. After their initial surprise, they argued and parted. This story is said to refer to the valued individuality of the Fulani people (Imperato 1973, 45).

An interesting technical detail in this cloth is that the selvedges have not been stitched together in the *dakol boderi* design (see detail). The stitching threads are deliberately knotted at each edge. This technique has yet to be explained.

5
Furnishing fabric
Possibly Hausa people,
Nigeria

Cotton plain weave with cotton
 inserted weft
88¾ x 48½ in. (225.4 x 123.2 cm)
Purchased with funds provided
 by the Smithsonian Institution
 Collection Acquisition
 Program, 1983–85
Lamb 1621 N
Collected in 1961 by Bernard
 Fagg

Materials
Ground warp: cotton machine-
 spun Z-twist, white
Ground weft: cotton handspun
 Z-twist, white, dark blue, blue
Inserted weft: cotton machine-
 spun Z-twist, orange, light
 orange

Techniques
Weft-faced plain weave with
 inserted weft
Proportions: 2 warps to 1 weft
 (dark blue), 2 wefts (white);
 inserted weft, bundles of 16
Thread count: warp pairs 13 per
 in. (5 per cm); weft pairs 33
 per in. (13 per cm)

Eight panels handsewn at
 selvedges; selvedge to selvedge
 width 5⅞ in. (14.9 cm)
Fringe: warp pairs unworked;
 length 1–1½ in. (2.5–3.8 cm)

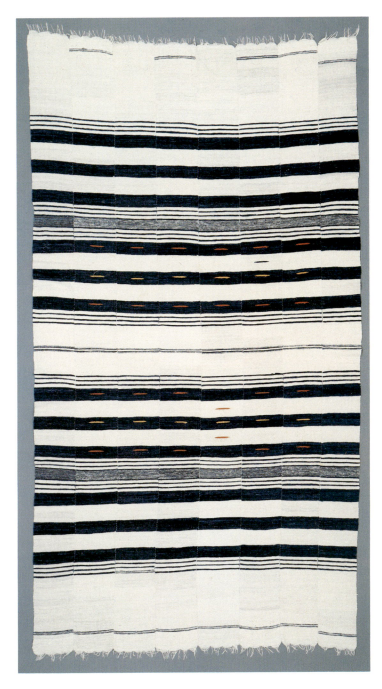

Although this piece exhibits traits typical of Fulani weaving,
the Lambs believe it was woven near Kano in northern
Nigeria, and Boser-Sarivaxévanis states that it is of Hausa
manufacture. It may have been woven in Nigeria under the
influence of cloths from the west, or it may have been
brought from the west into the Kano market.

6
Furnishing fabric
Fulani people,
Niger Bend region, Mali

Cotton and wool plain weave
 with cotton inserted weft,
 embroidered with wool and
 cotton
92⅝ x 52 in. (235.3 x 132.1 cm)
Museum purchase, 1986
National Museum of African
 Art, 86-1-1

Materials
Ground warp: cotton machine-
 spun Z-twist, white
Ground weft: wool handspun
 Z-twist, gray (undyed),
 brown; cotton machine-spun
 S-twist, white
Inserted weft: cotton machine-
 spun S-twist, yellow
Embroidery thread: wool
 handspun Z-twist, red-brown,
 dark brown; cotton machine-
 spun S-twist, white

Techniques
Weft-faced plain weave with
 inserted weft
Proportions: 1 warp to 1 weft
 (2 white)
Thread count: warp 12 per in.
 (5 per cm); weft 35 per in.
 (14 per cm)
Embroidered with thread pairs
 (red-brown and dark brown)
 and bundles of 16 pairs
 (white) in laid stitch

Six panels handsewn at
 selvedges; selvedge to selvedge
 width 8½ in. (21.6 cm)
Fringe: warp ends twisted across
 ends of cloth; sewing threads
 form braided tassels at the
 edge of each panel; length
 2½–3 in. (6.4–7.6 cm)

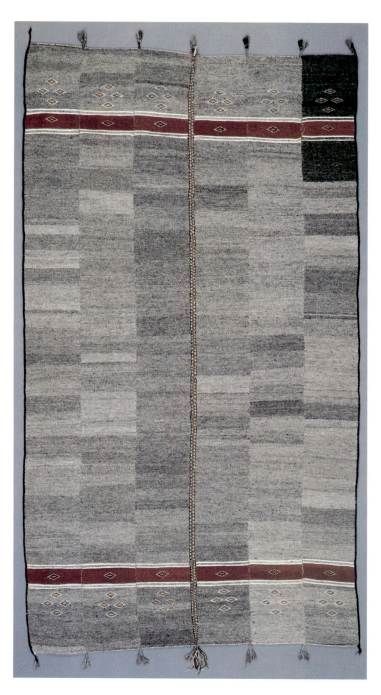

The natural color variations of wool enliven the com-
position of this *kaasa*. Like catalogue number 4, this cloth
uses wool braid to join the center seam and finish each
side. The customer provides the weaver with the thread for
weaving and any extra material, such as the wool braid.

7
Furnishing fabric
Mende people,
Sierra Leone

Cotton plain and tapestry
 weaves with cotton
 supplementary weft
80⅛ x 49⅝ in. (203.5 x 126 cm)
Purchased with funds provided
 by the Smithsonian Institution
 Collection Acquisition
 Program, 1983–85
Lamb 809 SL
Purchased in Yengema, Sierra
 Leone, in the 1930s

Materials
Ground warp: cotton handspun
 Z-twist, white
Ground weft: cotton handspun
 Z-twist, white, tan, dark blue,
 light blue, tan, dark yellow
Supplementary weft: cotton
 handspun Z-twist, dark blue,
 light blue

Techniques
Weft-faced plain and double-
 interlocked tapestry weaves
 with continuous
 supplementary weft
Proportions: 2 warps to 1 weft
Thread count: warp pairs 12
 per in. (5 per cm); weft 53
 per in. (21 per cm)
Supplementary weft passes over
 and under 3 warps in
 diamond twill weave

Nine panels handsewn at
 selvedges; selvedge to sel-
 vedge width 5⅜ in. (13.7 cm)
Fringe: warp pairs S-ply; length
 1¼ in. (3.2 cm)

Published
Venice and Alastair Lamb, *West
 African Narrow Strip Weaving*
 (Washington, D.C.: Textile
 Museum, 1975), 35, fig. 34.

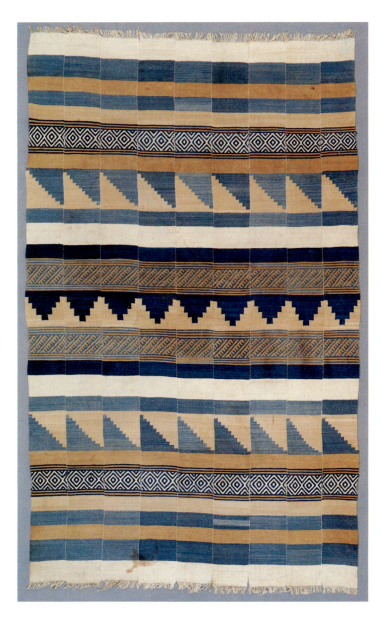

The composition of this piece connects it directly to the
north. The arrangement of patterns in stripes across the cloth
is a characteristic of both Fulani and North African weaving.
The use of a twill pattern also hints at a northern influence.

Tapestry weave, a structure that is not widely used south of
the Sahara, is another interesting feature of this cloth. It is
Boser-Sarivaxévanis' opinion that the technique was
transmitted to the south by the Fulani. The Mende, however,
are the only people of West Africa who have developed it on
a large scale.

8
Furnishing fabric
Possibly Mende people,
Sierra Leone

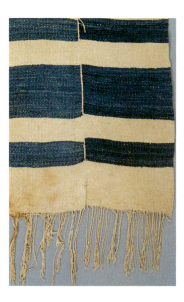

Cotton plain weave with cotton
 inserted weft, embroidered
 with cotton
72½ x 49 in. (184.2 x 124.5 cm)
National Museum of Natural
 History, T701

Materials
Ground warp: cotton handspun
 Z-twist, white, light blue
Ground weft: cotton handspun
 Z-twist, white, dark blue
Inserted weft and embroidery
 thread: cotton handspun Z-
 twist, white

Techniques
Weft-faced plain weave with
 inserted weft
Proportions: 2 warps to 1 weft
Thread count: warp pairs 12 per
 in. (5 per cm); weft 70 per in.
 (28 per cm)
Embroidered with a variation of
 feather stitch
Eight panels handsewn at
 selvedges; selvedge to selvedge
 width 5⅞–6¼ in. (14.9–15.9
 cm)
Fringe: 1 to 2 wrap pairs S-ply;
 length 3–4½ in (7.6–11.4 cm)

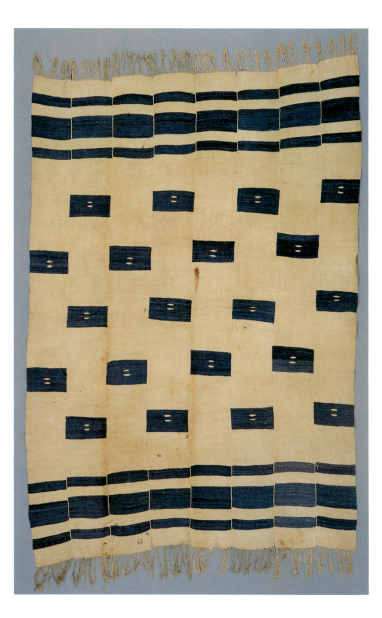

A checkerboard motif dominates the central field of this
piece. Lozenge designs are inserted in the dark blue blocks. In
the weft stripes at the top and bottom, the selvedges are
joined with an unusual embroidery stitch. Boser-
Sarivaxévanis has found this stitching technique elsewhere
only in Syrian and Coptic archaeological cloths (1980, 9).
She uses this information to support her view that cotton
cloth weaving on a horizontal loom passed from the Middle
East into West Africa.

 In addition to the unusual embroidery on this piece, some
ground warps are dyed. Three strips have white warps, four
strips have light blue warps, and one strip has warps that are
each partly white and partly blue.

9
Furnishing fabric
Vai people,
Liberia

Cotton plain weave with cotton
 inserted weft, embroidered
 with cotton
81 x 46 in. (205.7 x 116.8 cm)
Gift of Mr. and Mrs. Richard
 Flach, 1984
National Museum of African
 Art, 84-8-8

Materials
Ground warp: cotton handspun
 S-twist, white
Ground weft: cotton handspun
 Z-twist, white, dark blue;
 cotton handspun S-twist, blue
Inserted weft: cotton handspun
 S-twist, red, orange, yellow,
 light green, white
Embroidery thread: cotton
 handspun S-twist, white

Techniques
Weft-faced plain weave with
 inserted weft
Proportions: 1 warp to 1 weft
Thread count: warp 12 per in.
 (5 per cm); weft 65 per in.
 (26 per cm)
Embroidered with a variation of
 feather stitch

Nine panels handsewn at
 selvedges; selvedge to selvedge
 width 5 in. (12.7 cm)
Fringe: warp ends unworked;
 length 1⅝–2½ in. (4.1–6.4 cm)

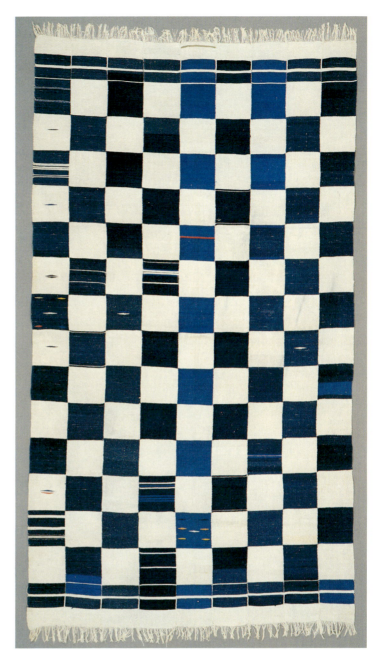

The basic dark and light alternating checks on this piece are
considerably enlivened by the insertion of bright orange, red,
and yellow threads. The checked central field, like that of
catalogue number 8, is edged with weft stripes at the top and
the bottom. This cloth, woven by the Vai people, is based on
a traditional Fulani design. It is the oldest of the Fulani
weaving styles, according to Boser-Sarivaxévanis. She
believes the design developed after the sixteenth century,
since none of the Bandiagara archaeological pieces has such a
pattern.

10
Furnishing fabric
Fulani people,
Niger Bend region, Mali

Cotton plain weave with cotton
supplementary weft
99 x 58 in. (251.5 x 147.3 cm)
Purchased with funds provided
by the Smithsonian Institution
Collection Acquisition
Program, 1983–85
Lamb 17 M
Purchased in Gao, Mali, in 1971

Materials
Ground warp: cotton machine-
spun S-twist, white
Ground weft: cotton machine-
spun S-twist, white, dark
blue, red, yellow, green
Supplementary weft: cotton
machine-spun S-twist, dark
blue

Techniques
Balanced plain weave with
continuous supplementary
weft
Proportions: 1 warp to 2 wefts
Thread count: warp 37 per in.
(15 per cm); weft pairs 42 per
in. (17 per cm)
Supplementary weft bundles of
6 pass over and under 2, 4,
and 8 warps

Seven panels handsewn at
selvedges; selvedge to selvedge
width 8⅛ in. (20.6 cm)
Fringe: warp ends unworked;
length 1½–2 in. (3.8–5 cm)

Published
Venice Lamb, *West African
Weaving* (London: Duckworth,
1975), 60, fig. 120.

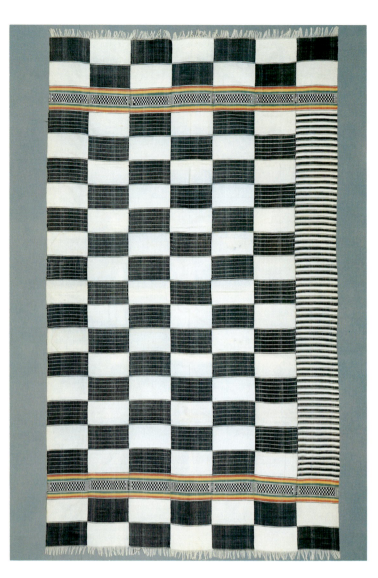

This cloth, according to the Lambs, was woven in either Diré
or Goundam near Timbuktu, Mali. Boser-Sarivaxévanis says
that it is the work of a Fulani weaver. A comparable cloth
has been called *sudumare walanieri*, "house writing board"
(Imperato 1979, 41), which refers to the cloth's function as a
household furnishing fabric and to an Islamic writing board.

This type of cloth is distinguished by the use of narrow
bands in dark rectangles. The rectangles are edged with dark
bands. On one side, the cloth has a strip of narrow bands, a pattern
found on many furnishing textiles from the Niger Bend
region and on some Bandiagara fabrics (Bedaux and Bolland
1980, fig. 20). This particular cloth's end bands are similar to
bands with small alternating units of blue and white seen on
Bandiagara cloths (Lamb 1975, fig. 135).

11
Furnishing fabric
Possibly Jula people,
Côte d'Ivoire

Cotton plain weave with cotton
 supplementary and inserted
 wefts
96⅜ x 61 in. (244.8 x 154.9 cm)
Purchased with funds provided
 by the Smithsonian Institution
 Collection Acquisition
 Program, 1983–85
Lamb 414 IC
Purchased in Bouaké, Côte
 d'Ivoire, in 1972

Materials
Ground warp: cotton machine-
 spun S-twist, white
Ground, supplementary, and
 inserted wefts: cotton
 machine-spun Z-twist, white;
 cotton machine-spun S-twist,
 blue-black

Techniques
Weft-faced plain weave with
 inserted and continuous
 supplementary wefts
Proportions: 1 warp to 2 wefts
Thread count: warp 15 per in.
 (6 per cm); weft pairs 20 to
 27 per in. (8 to 11 per cm)
Supplementary weft bundles of
 3 pass over and under 1, 2, 4,
 and 12 warps
Nine panels handsewn at
 selvedges; selvedge to selvedge
 width 6¾ in. (17.2 cm)
Fringe: warp ends unworked;
 length 1–1½ in. (2.5–3.8 cm)

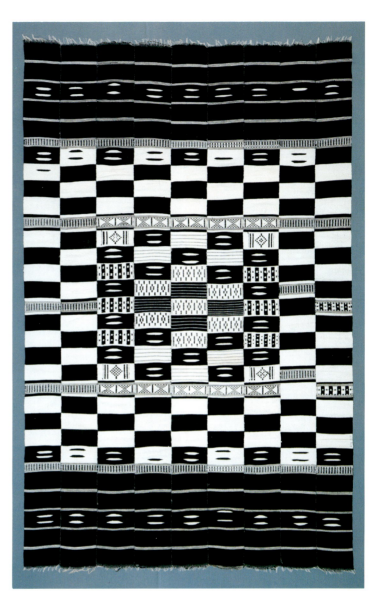

The composition and the design of this piece are typical of
central and northern Côte d'Ivoire, according to the Lambs.
They believe that it was woven by the Senufo, but it might
have been woven for the Senufo by the neighboring Jula.
Traditionally, the cotton threads for Jula weaving are grown,
spun, and dyed by the Senufo (Launay 1982, 41). Commercially
made yarns, however, are often used today, as in this cloth.

The intense color was achieved by repeatedly dipping the
threads in indigo dye, which is used throughout West Africa.
The patterns are strictly traditional, going back to models
from Bandiagara and North Africa. Unusual, however, is the
grouping of complicated patterns in the center of the field.
The centering of patterns in a checkerboard composition may
be based on Islamic ''magic squares'' (see p. 45).

12
Furnishing fabric
Mende people,
Sierra Leone

Cotton plain weave with cotton
supplementary weft
94 x 55¼ in. (238.8 x 140.3 cm)
Purchased with funds provided by
the Smithsonian Institution Col-
lection Acquisition Program,
1983–85
Lamb 1507 SL
Collected in Takoradi, Ghana, in
1941

Materials
Ground warp: cotton machine-
spun S-twist, white
Ground weft: cotton handspun Z-
twist, white, dark blue, light red,
yellow, light blue; cotton
machine-spun S-twist, yellow,
light red, white
Supplementary weft: cotton
machine-spun S-twist, yellow,
light red, white

Techniques
Weft-faced plain weave with
continuous and discontinuous
supplementary wefts
Proportions: 1 warp to 2 wefts
Thread count: warp 17 per in.
(7 per cm); weft pairs 45 per
in. (18 per cm) (white), and
50 per in. (20 per cm) (blue)
Supplementary weft bundles of
4 pass over and under 3, 4, 5,
7, 9, and 11 warps

Ten panels handsewn at
selvedges; selvedge to selvedge
width 5⅜ in. (13.7 cm)
Fringe: warp ends unworked;
length 1–3 in. (2.5–7.6 cm)

Published
Venice and Alastair Lamb, *Sierra
Leone Weaving* (Hertingford-
bury, England: Roxford
Books, 1984), 106–11.

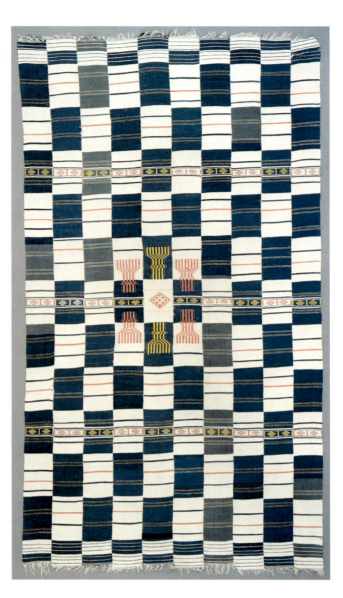

This piece is similar in design and composition to catalogue
number 11. The stripes in the blocks, the banding of
diamonds and bars, and the centralized composition point to
a northern weaving vocabulary. Northern designs may have
been introduced into coastal weaving during an invasion of
Mande-speaking people from the north between 1545 and
1606 (Rodney 1970, 64), or they may have entered earlier
through trade.

The pattern formed by the light red and yellow threads in
the center seems to be closely related to the "hand of
Fatima" motif found on many Moroccan cloths to protect the
wearer from the so-called evil eye (Gilfoy 1983, 196–210).
This may be an example of the creative mixing of Islamic and
local religious cultures that has occurred in many areas of
West Africa.

13
Furnishing fabric
Mende people,
Sierra Leone

Cotton plain weave with cotton
 supplementary weft
82⅛ x 47¼ in. (209.2 x 120 cm)
Purchased with funds provided
 by the Smithsonian Institution
 Collection Acquisition
 Program, 1983–85
Lamb 822 SL
Collected in Sierra Leone in
 1934

Materials
Ground warp: cotton handspun
 Z-twist, white
Ground weft: cotton handspun
 Z-twist, white, dark blue
Supplementary weft: cotton
 handspun Z-twist, dark blue,
 tan

Techniques
Warp-faced plain weave with
 discontinuous supplementary
 weft in diamond and
 herringbone twill weaves
Proportions: 1 warp to 1 weft
 (some warps are bundles of 7
 threads)
Thread count: warp 22 per in.
 (9 per cm); weft 50 per in.
 (20 per cm)
Supplementary weft pairs and
 bundles of 4 pass over 3
 under 1 warps (diamond
 twill) and over 3 under 2
 warps (herringbone twill)
Fifteen panels handsewn at
 selvedges; selvedge to selvedge
 width 3 in. (7.6 cm)
Fringe: warp ends unworked;
 length ⅜–1 in. (1–2.5 cm)

Published
Venice and Alastair Lamb, *Sierra
 Leone Weaving* (Hertingford-
 bury, England: Roxford
 Books, 1984), 107–11.

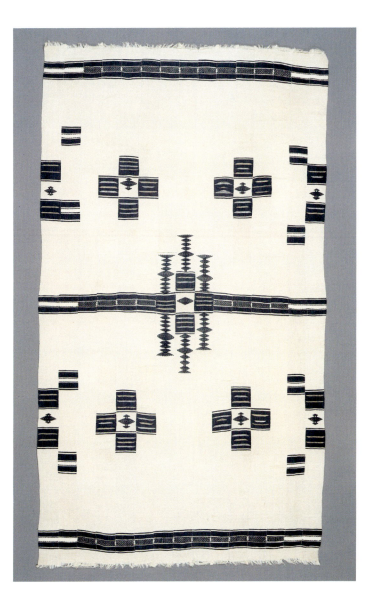

This cloth owes much of its design inspiration to northern Fulani wool blankets (see cat. no. 4). North African influences are also evident in the diamond and lozenge designs and the twill-weave structure.

The surface variations woven into the fabric and the composition display a great deal of subtlety. In each strip, every eighth warp is a bundle of seven threads except in the central portion, which has a wider span of thirteen warps between bundled warps. The warp bundles occur six times in a strip, creating textural ridges the length of the cloth. In addition, weft insertion and several versions of twill weave are used. Finally, although at first glance the composition appears rigidly arranged, the placement of the elements is slightly varied over the face of the cloth.

14
Wrapper
Asante people, Ghana

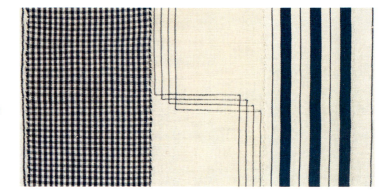

Cotton plain weave with cotton
 supplementary warp/weft
71½ x 50½ in. (181.6 x 128.3 cm)
Purchased with funds provided
 by the Smithsonian Institution
 Collection Acquisition
 Program, 1983–85
Lamb 528 GA
Purchased in Bonwire, Ghana,
 in 1972

Materials
Ground warp: cotton machine-
 spun S-twist, white, dark blue
Ground weft: cotton machine-
 spun S-twist, white, dark blue
Supplementary warp/weft:
 cotton machine-spun S-twist,
 dark blue

Techniques
Balanced (checked panels) and
 warp-faced plain weaves with
 supplementary weft/warp
 (four spaced pairs of
 supplementary warps change
 to supplementary wefts,
 known as the "liar's pattern")
Proportions: 1 warp to 1 weft
Thread count: warp 78–86 per
 in. (31–34 per cm); weft
 58–72 per in. (23–28 per cm)
Supplementary weft/warp passes
 over and under 1 warp or weft
Sixteen panels handsewn at
 selvedges; selvedge to selvedge
 width 3–3½ in. (7.6–8.9 cm)
Bottom and top edges machine-
 hemmed

Published
Venice and Alastair Lamb,
 "West African Textiles," *Crafts*
 (May–June 1975): 22.

The name of an Asante cloth derives from the dominant warp pattern. The Lambs call this cloth *mmaban*, "mixed," indicating that a number of warp patterns are used. Boser-Sarivaxévanis notes that this piece may have been woven in Bonwire or in Agbozume, a town on the southeast coast of Ghana.

Four strips in this cloth have the so-called liar's pattern, *nkontompo ntama*. Four pairs of dark blue threads, each spaced by four white warps, begin as warps but change direction at intervals to become wefts. The shift from one direction to the other is accomplished by knotting the blue threads. "The King of Ashanti is said to have worn this pattern when holding court, to confute persons of doubtful veracity who came before him" (Rattray 1927, 244).

The pattern with blue and white checks is called "*kotwa* (the scar); also called *asambo* (the guinea fowl's breast), and *asam takra* (the guinea fowl's feathers). . . .[It is] only worn by chiefs" (Rattray 1927, 248). Found on some Bandiagara archaeological cloths, the pattern was incorporated into the West African weaving tradition by the eleventh century (fig. 8, p. 23). In addition, this cloth's narrow strips are as finely structured as those of the Bandiagara cloths.

Checks, as well as stripes, are also found on seventeenth- and eighteenth-century Indian cotton cloths traded in West Africa, which were referred to as guinea stuff or guinea cloths by European traders. The cloths, mostly blue and white fabrics, were of coarse quality (Chaudhuri 1978, 501), unlike this finely woven West African cloth. Some actually may have been made in Europe for the West African trade. The Getty Archives for the History of Art has a letter dated 3 June 1786 from Abraham Durninguer to Mr. Schoch in Leipzig, Germany, that includes swatches of cotton cloths that are similar to the Indian cloths. "We have the honor of sending you the enclosed samples of dyed blue cotton cloth and cloth with threads in stripes and checks in colors like those we sent to Nantes [France] for the commerce of the African coast," Durninguer wrote. It is possible, of course, that the cloths mentioned in the letter were obtained in India and Durninguer was merely an agent.

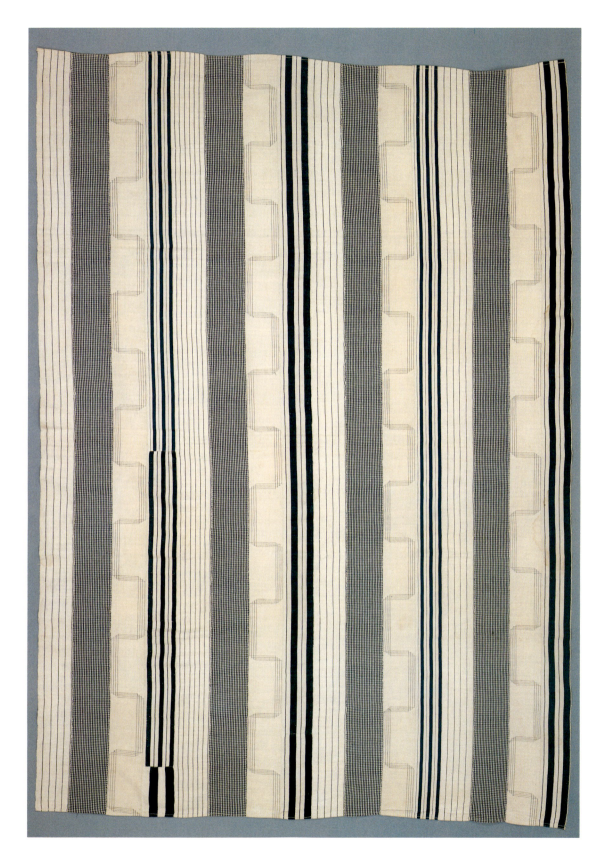

15
Wrapper
Asante people, Ghana

Cotton plain weave with cotton
 supplementary warp
95 x 62¼ (241.3 x 158.1)
Purchased with funds provided
 by the Smithsonian Institution
 Collection Acquisition
 Program, 1983–85
Lamb 233 GA
Purchased in Bonwire, Ghana,
 in 1971

Materials
Ground warp: cotton machine-
 spun S-twist, white, light
 blue, dark blue
Ground weft: cotton machine-
 spun S-twist, white, dark blue
Supplementary warp: cotton
 machine-spun S-twist, dark
 blue

Techniques
Warp-faced plain weave with
 supplementary warp
Proportions: 1 warp to 1 weft
Thread count: warp 70–110 per
 in. (28–43 per cm); weft
 32–47 per in. (13–19 per cm)
Supplementary warp passes over
 and under 1 weft

Nineteen panels handsewn at
 selvedges; selvedge to selvedge
 width 2⅞–3⅝ in. (7.3–9.2
 cm)
Bottom and top edges hand-
 hemmed

Published
Venice Lamb, *West African
 Weaving* (London: Duckworth,
 1975), 105, fig. 167.

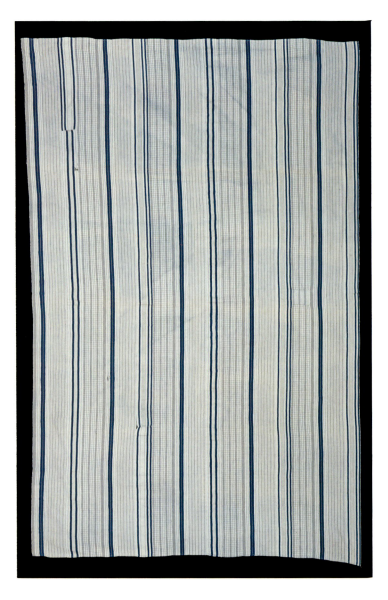

The blue supplementary warp used in this piece sharply
defines the wide blue warp stripes. Another interesting
feature is the small piece of cloth with a different pattern that
fills in the end of one of the strips. Someone other than the
weaver usually assembles narrow-strip cloths. In many areas,
sewers are former weavers who are too old to work a loom.
The sewer is often responsible for creating the offbeat design
accents in West African cloths.

16
Wrapper
Asante people, Ghana

Cotton and cotton/silk plain
 weave
93⅛ x 60¾ in. (236.5 x 154.3
 cm)
Purchased with funds provided
 by the Smithsonian Institution
 Collection Acquisition
 Program, 1983–85
Lamb 248 GA
Purchased in Bonwire, Ghana,
 in 1971

Materials
Ground warp: cotton machine-
 spun S-twist, dark blue, light
 blue, white; cotton/silk
 handspun Z-twist, dark red
Ground weft: cotton machine-
 spun S-twist, white, blue

Techniques
Warp-faced plain weave
Proportions: 1 warp to 1 weft (2
 wefts, white)
Thread count: warp 98 per in.
 (39 per cm); weft 45 per in.
 (18 per cm)

Eighteen panels handsewn at
 selvedges; selvedge to selvedge
 width 3⅜ per in. (8.6 per cm)
Bottom and top edges hand-
 hemmed

Published
Venice Lamb, *West African
 Weaving* (London: Duckworth,
 1975), 117, fig. c.
Venice and Alastair Lamb, *West
 African Narrow Strip Weaving*
 (Washington, D.C.: Textile
 Museum, 1975), 45, fig. 53.

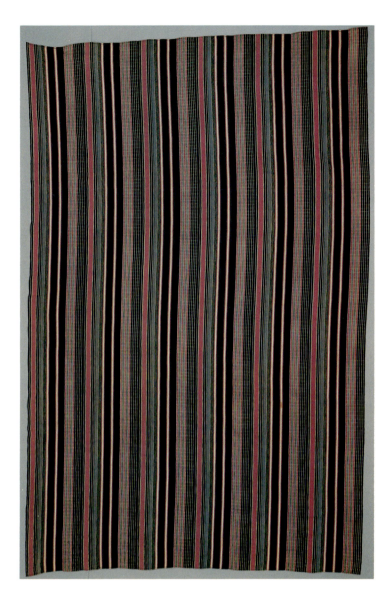

The dark red warp stripes in this cloth are a mixture of spun
silk (probably Mediterranean waste silk) and undyed cotton
(see cat. no. 21). Cotton fibers were added during spinning to
extend the silk. Warp stripes dominate the design, but the
addition of subtle checks creates variety.

17
Wrapper
Asante people, Ghana

Cotton plain weave
105⅛ x 71 in. (267 x 180.3 cm)
Purchased with funds provided
 by the Smithsonian Institution
 Collection Acquisition
 Program, 1983–85
Lamb 245 GA
Purchased in Bonwire, Ghana,
 in 1971

Materials
Ground warp: cotton machine-
 spun S-twist, white, blue
Ground weft: cotton machine-
 spun S-twist, white, blue

Techniques
Balanced plain weave
Proportions: 1 warp to 1 weft
Thread count: warp 70 per in.
 (28 per cm); weft 57 per in.
 (22 per cm)

Twenty panels handsewn at
 selvedges; selvedge to selvedge
 width 3⅝ in. (9.2 cm)
Bottom and top edges machine-
 hemmed

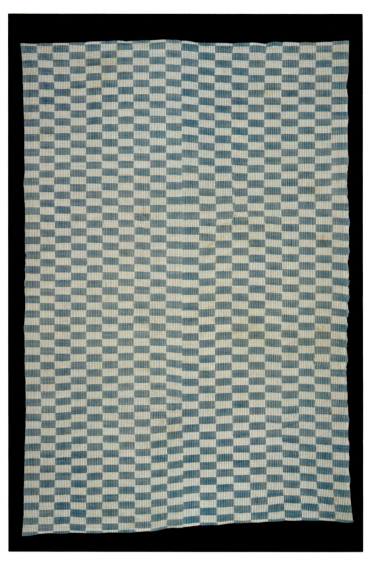

The sewer of this cloth began with a regular checkerboard design, but in the center of the cloth he varied the placement of the squares to create visual rhythm. In traditional use, this textile was wrapped around the body, altering the appearance of the pattern. Thus, the broken rhythm of the design would have been further enhanced by wrapping and movement.

18
Wrapper
Asante people, Ghana

Cotton plain weave with cotton
 inserted and supplementary
 wefts
81¼ x 46¼ in. (206.4 x 117.5 cm)
Purchased with funds provided
 by the Smithsonian Institution
 Collection Acquisition
 Program, 1983–85
Lamb 239 GA
Purchased in Bonwire, Ghana,
 in 1971

Materials
Ground warp: cotton machine-
 spun S-twist, white, dark
 blue, light blue; cotton
 handspun S-twist, white
Ground weft: cotton machine-
 spun S-twist, white
Complementary weft: cotton
 machine-spun S-twist, dark
 blue; cotton handspun
 S-twist, white, dark blue
Supplementary weft: cotton
 machine-spun S-twist, dark
 blue
Inserted weft: cotton handspun
 S-twist, dark blue

Techniques
Warp- and weft-faced plain
 weaves with inserted and
 supplementary wefts
Proportions: 1 warp to 1 weft, 3
 warp and weft pairs (white),
 inserted weft pairs (dark blue)
Thread count: warp 97 per in.
 (38 per cm); weft 80 per in.
 (32 per cm)
Complementary weft bundles of
 3 pass over and under 4, 6,
 and 8 warps
Supplementary weft passes over
 and under 6 warps
Sixteen panels handsewn at
 selvedges; selvedge to selvedge
 width 2⅝–3¼ in. (6.7–8.3 cm)
Bottom and top edges hand-
 hemmed

Published
Herbert M. Cole and Doran H.
 Ross, *The Arts of Ghana* (Los
 Angeles: Museum of Cultural
 History, 1977), 38, fig. 57.

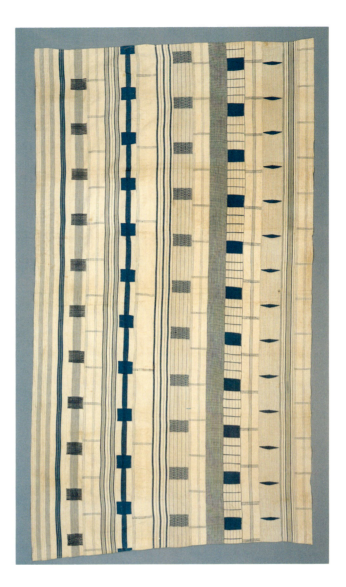

Wide and narrow weft bands occur on a variety of warp stripe designs in this finely woven cloth, creating a dramatic nonrepetitive composition. In one strip, lozenge-shaped patterns are created by the addition of an inserted supplementary weft that deflects the regular weft, a technique used regularly in textiles of the Western Sudan region and North Africa. Moreover, thicker threads are inserted at measured intervals to give the fabric subtle textural variations.

The windowpane check pattern along the right side of this cloth is called *nsafoasia*, ''the six keys.'' It was ''formerly worn by the king's treasurers'' (Rattray 1927, 248). The pattern in the fourth panel from the right is known as *nsafoasa*, ''the three keys.'' The next strip with the large checks and broad weft bands is called *nkatewasa*, ''the *nkatewa* seeds have come to an end'' (Rattray 1927, 246).

19
Wrapper
Asante people, Ghana

Cotton plain weave with cotton
 supplementary wefts
81 x 53 in. (205.7 x 134.6 cm)
Purchased with funds provided
 by the Smithsonian Institution
 Collection Acquisition
 Program, 1983–85
Lamb 232 GA
Purchased in Bonwire, Ghana,
 in 1971

Materials
Ground warp: cotton machine-
 spun S-twist, dark blue, light
 blue, white
Ground weft: cotton machine-
 spun S-twist, dark blue, white
Complementary and
 supplementary wefts: cotton
 machine-spun S-twist, white

Techniques
Warp- and weft-faced plain
 weaves with weft wrapping and
 discontinuous supplementary
 weft
Proportions: 1 warp to 1 weft
Thread count: warp 120 per in.
 (47 per cm); weft 52 per in.
 (21 per cm)
Complementary and
 supplementary wefts pass over
 and under 6 and 8 warps
Weft wrapping: bundles of 12
 wrap around 6 warps
Seventeen panels handsewn at
 selvedges; selvedge to selvedge
 width 3¼ in. (8.3 cm)
Fringe: 36–76 warp ends Z-
 twist; length 4–6 in. (10.2–
 15.2 cm); and 2 weft-wrap
 bundles of 24 Z-twist; length
 6–7 in. (15.2–17.8 cm)
Top edge hand-hemmed

Published
Venice Lamb, *West African
 Weaving* (London: Duckworth,
 1975), 113, fig. 191.
Venice and Alastair Lamb, *West
 African Narrow Strip Weaving*
 (Washington, D.C.: Textile
 Museum, 1975), 15, fig. 11.
Herbert M. Cole and Doran H.
 Ross, *The Arts of Ghana* (Los
 Angeles: Museum of Cultural
 History, 1977), 41, fig. 63.

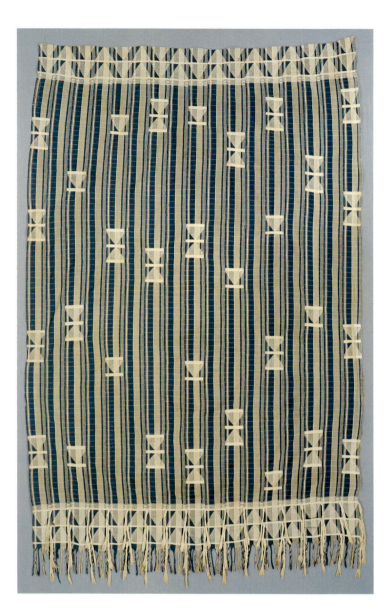

This cloth shows a northern influence. Boser-Sarivaxévanis believes that this type of cloth links the weaving tradition of Mali with Asante and Ewe weaving. The hourglass patterns in the central field are directly related to geometric motifs found in textiles from North Africa (see fig. 19, p. 44) and from the Western Sudan region, including Bandiagara. Contrasting the carefully matched end borders, the hourglass patterns are asymmetrically placed for visual excitement.

The Lambs consider this to be a woman's wrapper, but it is also known that men wear fringed cloths. Although the fringes on the top end of this cloth were cut off, traces can still be seen.

20
Wrapper
Asante people, Ghana

Cotton plain weave with cotton
 supplementary wefts
88⅛ x 51½ in. (223.8 x 130.8 cm)
Purchased with funds provided
 by the Smithsonian Institution
 Collection Acquisition
 Program, 1983−85
Lamb 296 GA
Purchased in Bonwire, Ghana,
 in 1969

Materials
Ground warp: cotton machine-
 spun S-twist, dark blue, white
Ground weft: cotton machine-
 spun S-twist, dark blue
Complementary and
 supplementary wefts: cotton
 machine-spun S-twist, white

Techniques
Warp-faced plain weave with
 weft wrapping and
 discontinuous supplementary
 weft
Proportions: 1 warp to 1 weft
Thread count: warp 100 per in.
 (39 per cm); weft 42 per in.
 (17 per cm)
Complementary and
 supplementary wefts pass over
 and under 8 warps
Weft wrapping: bundles of 16
 wrap around 16 warps

Eighteen panels handsewn at
 selvedges; selvedge to selvedge
 width 3 in. (7.6 cm)
Fringe: 30−72 warp ends Z-ply;
 length 6−6⅜ in. (15.2−16.2
 cm); and 6 or 8 16-thread
 weft-wrap bundles Z-ply;
 length 8−10½ in. (20.3−26.7
 cm)
Top edge hand-hemmed

Published
Venice Lamb, *West African
 Weaving* (London: Duckworth
 Press, 1975), 113, fig. 190.

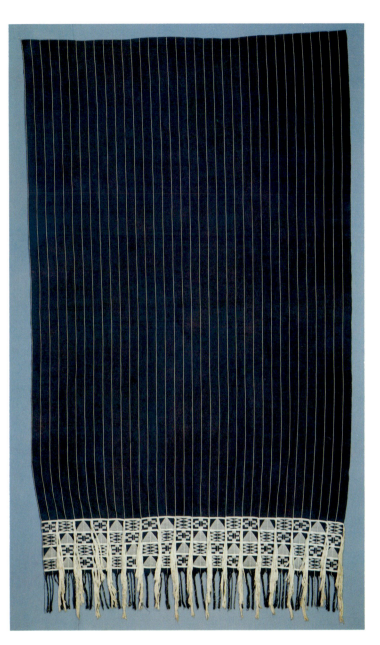

The patterns on this cloth, like those in catalogue number
19, are created by supplementary weft threads that pass over
and under groups of warps, a technique that makes them
more noticeable. Asante weavers, it is reported, calculate the
width of their strips by counting these groups, usually four
threads each, rather than by counting each thread (Hale
1977, 28). The end-band designs are seen in other Asante
cloths, especially catalogue numbers 23, 27, 32, and 36.

21
Wrapper
Asante people, Ghana

Cotton and cotton/silk plain
weave with cotton
supplementary weft
88 x 54⅛ in. (223.5 x 137.5 cm)
Purchased with funds provided
by the Smithsonian Institution
Collection Acquisition
Program, 1983–85
Lamb 246 GA
Purchased in Bonwire, Ghana,
in 1971

Materials
Ground warp: cotton machine-
spun Z-twist, dark blue,
white, light blue, gray, light
yellow; cotton/silk handspun
Z-twist, magenta
Ground weft: cotton machine-
spun Z-twist, dark blue, white
Complementary and
supplementary wefts: cotton
machine-spun Z-twist, white

Techniques
Balanced, warp-faced, and weft-
faced plain weaves with
discontinuous supplementary
weft
Proportions: 1 warp to 1 weft
Thread count: warp 70–75 per
in. (28–30 per cm); weft
50–55 per in. (20–22 per cm)
Complementary weft and single,
paired, and tripled
supplementary wefts pass over
and under 6, 8, and 10 warps
Sixteen panels handsewn at
selvedges; selvedge to selvedge
width 3⅜–3⅝ in. (8.6–9.2 cm)
Top and bottom edges machine-
hemmed

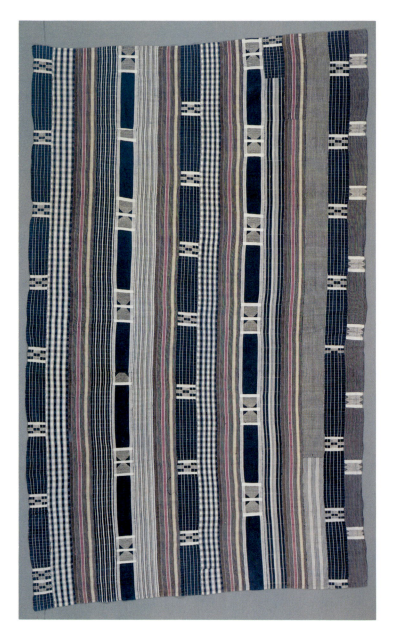

The magenta warp stripes in this piece are composed of spun
silk (probably imported waste silk) and either cotton or a bast
fiber (see cat. no. 16). The asymmetrical composition includes
motifs found also in catalogue numbers 19 and 20.

This cloth is not as well planned as some of the others. In
three places, it appears that the sewer ran out of material for
the full length of the strip, so he had to add a segment to
finish it. One strip does not occur elsewhere in the cloth,
perhaps suggesting that the customer wanted the cloth to be
larger than originally ordered.

22
Wrapper
Asante people, Ghana

Cotton plain weave with cotton
 supplementary weft
84½ x 52⅜ in. (214.6 x 133 cm)
Purchased with funds provided
 by the Smithsonian Institution
 Collection Acquisition
 Program, 1983–85
Lamb 236 GA
Purchased in Bonwire, Ghana,
 in 1971

Materials
Ground warp: cotton machine-
 spun S-twist, dark blue, light
 blue, white
Ground weft: cotton machine-
 spun S-twist, dark blue, white
Complementary and
 supplementary wefts: cotton
 machine-spun S-twist, white

Techniques
Warp- and weft-faced plain
 weaves with discontinuous
 supplementary weft
Proportions: 1 warp to 1 weft
Thread count: warp 80 per in.
 (32 per cm); weft 50 per in.
 (20 per cm)
Complementary weft pairs and
 supplementary weft bundles
 of 4 pass over and under 8
 warps
Sixteen panels handsewn at
 selvedges; selvedge to selvedge
 width 3⅛–3⅜ (7.9–8.6 cm)
Top and bottom edges hand-
 hemmed

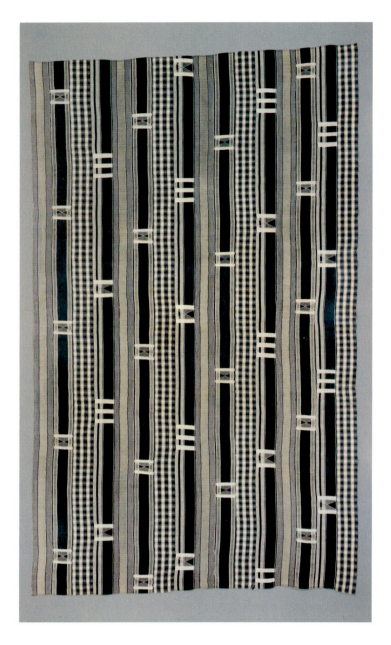

Compared with the predominance of white in previous
examples, the basic tonality of this cloth is dark blue. White
weft bands, narrow stripes, and small checks create accents.
Groups of bands range diagonally across the cloth without
falling into a checkerboard arrangement. Although at first this
composition appears to be regular, there are subtle variations
within the design structure.

73

23
Wrapper
Asante people, Ghana

Cotton plain weave with cotton
 supplementary weft
72⅞ x 50 in. (185.1 x 127 cm)
Museum purchase, 1974
National Museum of African
 Art, 74-31-16
Purchased in Bonwire, Ghana,
 in 1974

Materials
Ground warp: cotton machine-
 spun S-twist, white, dark blue
Ground weft: cotton machine-
 spun S-twist, white
Complementary weft: cotton
 machine-spun S-twist, white
Supplementary weft: cotton
 handspun S-twist, dark blue

Techniques
Balanced and weft-faced plain
 weaves with continuous and
 discontinuous supplementary
 wefts
Proportions: 1 warp to 1 weft
Thread count: warp 28 per in.
 (11 per cm); weft 18 per in.
 (7 per cm)
Complementary wefts and
 supplementary weft bundles
 of 3 pass over and under 6
 and 8 warps

Fourteen panels handsewn at
 selvedges; selvedge to selvedge
 width 3½–3⅝ in. (8.9–9.2 cm)
Fringe: warp ends unworked;
 length ⅜–½ in. (1–1.3 cm)

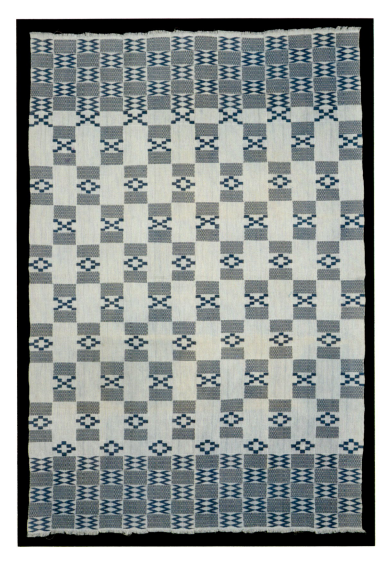

The weaver of this piece, using designs similar to those in catalogue number 20, placed dramatic blocks on top of very fine warp stripes of alternating dark blue and white. Boser-Sarivaxévanis suggests that this cloth, purchased in Bonwire, may have been made in Liberia by the Vai.

24
Wrapper
Asante people, Ghana

Cotton plain weave with cotton
 supplementary weft
70¼ x 46⅛ in. (178.4 x 117.2 cm)
Purchased with funds provided
 by the Smithsonian Institution
 Collection Acquisition
 Program, 1983–85
Lamb 227 GA
Purchased in Bonwire, Ghana,
 in 1971

Materials
Ground warp: cotton machine-
 spun S-twist, white, dark blue
Ground weft: cotton machine-
 spun S-twist, white
Complementary weft: cotton
 machine-spun S-twist, white
Supplementary weft: cotton
 machine-spun S-twist, dark
 blue

Techniques
Balanced and weft-faced plain
 weaves with continuous and
 discontinuous supplementary
 wefts
Proportions: 1 warp to 1 weft
Thread count: warp 75 per in.
 (30 per cm); weft 62 per in.
 (24 per cm)
Complementary and
 supplementary wefts pass over
 and under 4, 6, and 8 warps
Fourteen panels handsewn at
 selvedges; selvedge to selvedge
 width 3¼–3½ in. (8.3–8.9 cm)
Fringe: warp ends unworked;
 length ¼–½ in. (.6–1.3 cm)

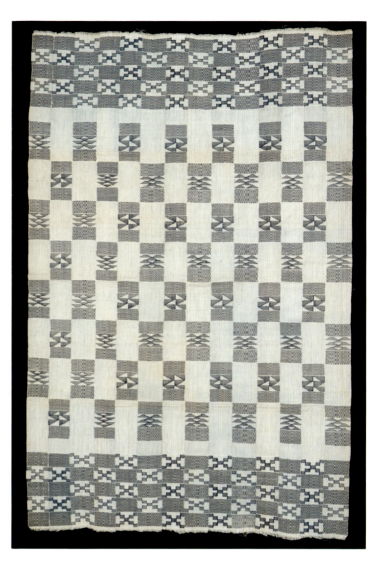

Although at first it appears that a rigid composition was
intended, the weaver slightly altered the order of some of the
design units on the strips to create visual variety. In addition,
the person who assembled the cloth heightened the lively
effect by turning some of the strips in the opposite direction.

25
Wrapper
Asante people, Ghana

Cotton and silk plain weave
with cotton and silk
supplementary weft
64⅛ x 37 in. (162.9 x 94 cm)
Purchased with funds provided
by the Smithsonian Institution
Collection Acquisition
Program, 1983−85
Lamb 197 GA
Purchased in Bonwire, Ghana,
in 1971

Materials
Ground warp: cotton machine-
spun S-twist, white, dark blue
Ground weft: cotton machine-
spun S-twist, white, dark blue
Complementary weft: cotton
machine-spun S-twist, blue,
light blue, yellow, dark green,
purple, light purple, tan, dark
brown, brown
Supplementary weft: cotton
machine-spun S-twist, dark
green, light purple, tan, gray,
brown
Supplementary and
complementary wefts: silk
machine-spun Z-twist, yellow,
yellow-green, dark red

Techniques
Balanced, warp-faced, and weft-
faced plain weaves with
discontinuous supplementary
weft
Proportions: 1 warp to 1 weft
Thread count: warp 86−90 per
in. (34−35 per cm); weft
50−56 per in. (20−22 per cm)
Complementary and
supplementary wefts (some
paired) pass over and under 6
and 8 warps
Twelve panels handsewn at
selvedges; selvedge to selvedge
width 3⅛ in. (7.9 cm)
Top and bottom edges machine-
hemmed

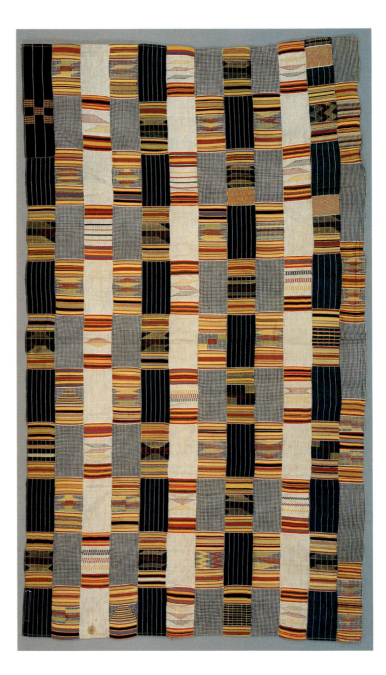

In this piece the rectangular decorative units are
symmetrically placed for a checkerboard effect. The sewer
who joined the strips, however, did not match them to
align background colors symmetrically.

26
Wrapper
Asante people, Ghana

Cotton and silk plain weave
 with cotton and silk
 supplementary weft
51⅝ x 32¼ in. (131.1 x 81.9 cm)
Purchased with funds provided
 by the Smithsonian Institution
 Collection Acquisition
 Program, 1983−85
Lamb 199 GA
Purchased in Bonwire, Ghana,
 in 1971

Materials
Ground warp: cotton machine-
 spun Z-twist, dark blue,
 white, red, light blue
Ground weft: cotton machine-
 spun Z-twist, dark blue, white
Supplementary weft/warp (liar's
 pattern): cotton machine-spun
 Z-twist, white
Complementary weft: cotton
 machine-spun Z-twist, tan,
 red, white, black, yellow
Supplementary weft: cotton
 machine-spun S-twist, tan,
 red
Complementary and
 supplementary wefts:
 unraveled silk machine-spun
 Z-twist, yellow

Techniques
Warp- and weft-faced plain
 weaves with discontinuous
 supplementary weft
Proportions: 1 warp to 1 weft
Thread count: warp 75−92 per
 in. (30−36 per cm); weft
 47−75 per in. (19−30 per cm)
Supplementary weft/warp passes
 over and under 1
Complementary and
 supplementary weft pairs pass
 over and under 4, 6, and 8
 warps

Nine panels handsewn at
 selvedges; selvedge to
 selvedge width 3¼−3⅞ in.
 (8.3−9.8 cm)
Top and bottom edges hand-
 hemmed

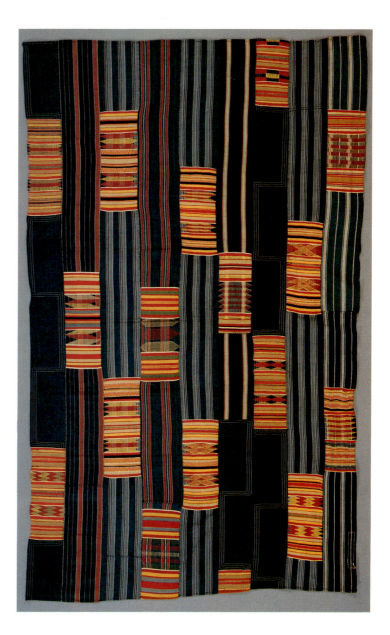

The composition of this cloth is a radical departure from the balanced warp and weft designs illustrated on the other Asante cotton textiles. The weft-band blocks are greatly expanded on the strips, a style that probably began in the early eighteenth century (McLeod 1981, 155). The dark background recedes, dominated by the scattered, brightly colored embellishments.

The yellow silk supplementary weft threads in this cloth were probably unraveled from an imported cloth (see cat. nos. 28 and 31). The threads show crimping, evidence of their previous structure. In addition, some spots along the threads have less dye, a further hint that the silk was dyed after it had been woven into the original cloth.

27
Wrapper
Asante people, Ghana

Silk plain weave with silk
 supplementary weft
57 x 21 in. (144.8 x 53.3 cm)
Purchased with funds provided
 by the Smithsonian Institution
 Collection Acquisition
 Program, 1983–85
Lamb 301 GA
Purchased in Bonwire, Ghana,
 in 1970

Materials
Ground warp: silk machine-
 spun Z-twist, white, blue
Ground weft: silk machine-spun
 Z-twist, white
Complementary weft: silk
 machine-spun Z-twist, red,
 yellow, yellow-green, white,
 dark blue, dark brown
Supplementary weft: silk
 machine-spun Z-twist, red,
 yellow, yellow-green, dark
 blue, dark brown

Techniques
Warp- and weft-faced plain
 weaves with complementary
 and discontinuous
 supplementary wefts
Proportions: 1 warp to 1 weft
Thread count: warp 60 per in.
 (24 per cm); weft 42 per in.
 (17 per cm)
Complementary and
 supplementary weft pairs pass
 over and under 4 warps

Six panels handsewn at
 selvedges; selvedge to selvedge
 width 3½ in. (8.9 cm)
Top and bottom edges hand-
 hemmed

Published
Herbert M. Cole and Doran H.
 Ross, *The Arts of Ghana* (Los
 Angeles: Museum of Cultural
 History, 1977), 39, fig. 59.

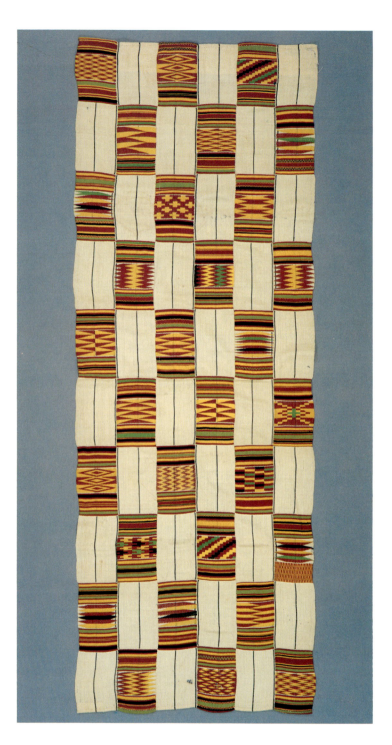

This cloth is a woman's scarf, according to the Lambs.
Women frequently wear a pair of cloths, one as a body
wrapper and another smaller one as a scarf or shoulder piece.
This piece retains an overall symmetry. It is borderless either
because it is a woman's shoulder wrap or because it is cut
from a large man's mantle.

28
Wrapper
Asante people, Ghana

Cotton and silk plain weave
with cotton supplementary
weft
54¼ x 32 in. (139.1 x 81.3 cm)
Purchased with funds provided
by the Smithsonian Institution
Collection Acquisition
Program, 1983−85
Lamb 303 GA
Purchased in Bonwire, Ghana,
in 1969

Materials
Ground warp: cotton machine-
spun S-twist, dark blue,
white, red, yellow, green
Ground weft: cotton machine-
spun S-twist, dark blue, white
Complementary weft: cotton
machine-spun S-twist, green,
red, yellow, white, dark blue,
light green, light red, light
blue; unraveled silk machine-
spun Z-twist, yellow
Supplementary weft: cotton
machine-spun S-twist, green,
red, yellow, dark blue, light
green, light red, light blue

Techniques
Warp- and weft-faced plain
weaves with complementary
and discontinuous
supplementary wefts
Proportions: 1 warp to 1 weft
Thread count: warp 77−100 per
in. (30−39 per cm); weft
58−77 per in. (23−30 per cm)
Complementary and
supplementary weft pairs and
bundles of 3 pass over and
under 8 warps
Ten panels handsewn at selvedges;
selvedge to selvedge width
2⅞−3½ in. (7.3−8.9 cm)
Top and bottom edges hand-
hemmed

Published
Venice Lamb. *West African
Weaving* (London: Duckworth
Press, 1975), 117, fig. e.

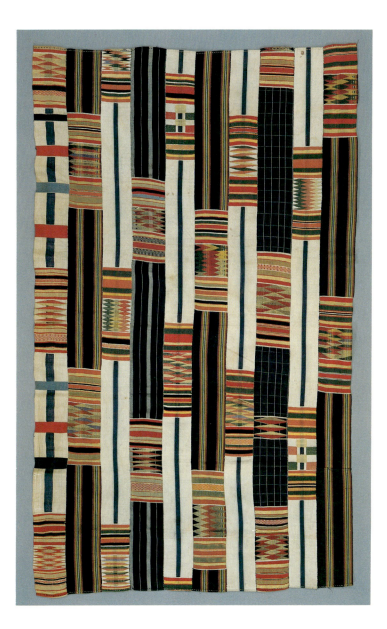

This piece features a diagonal alignment of decorative units, not the usual checkerboard, and a dramatic combination of brilliant color against dark blue and white. The yellow supplementary threads are probably unraveled from an imported silk cloth (see cat. nos. 26 and 31).

29
Wrapper
Asante people, Ghana

Cotton and silk plain weave
 with cotton and silk
 supplementary weft
78¼ x 49⅝ in. (198.8 x 126 cm)
Purchased with funds provided
 by the Smithsonian Institution
 Collection Acquisition
 Program, 1983–85
Lamb 302 GA
Purchased in Bonwire, Ghana,
 in 1970

Materials
Ground warp: cotton machine-
 spun S-twist, dark blue, white
Ground weft: cotton machine-
 spun S-twist, dark blue, white
Complementary weft: cotton
 machine-spun S-twist, white,
 red, dark blue
Supplementary weft: cotton
 machine-spun S-twist, red,
 dark blue
Complementary and
 supplementary wefts:
 unraveled silk machine-spun
 Z-twist, yellow, light yellow-
 green, light blue

Techniques
Warp- and weft-faced plain
 weaves with discontinuous
 supplementary weft
Proportions: 1 warp to 1 weft
Thread count: warp 90 per in.
 (35 per cm); weft 55 per in.
 (22 per cm)
Complementary and
 supplementary wefts pass over
 and under 8 warps

Seventeen panels handsewn at
 selvedges; selvedge to selvedge
 width 2⅞–3½ in. (7.3–8.9 cm)
Top and bottom edges hand-
 hemmed

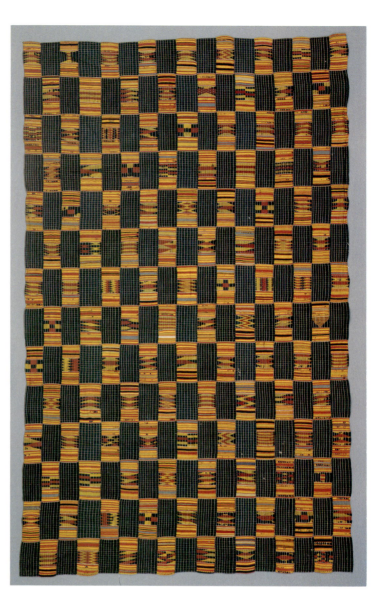

This cloth demonstrates that a rigid symmetrical pattern is possible without a border. The numerous designs between blocks of weft bands and the unique color scheme of each block vary the rhythm of the checkerboard pattern. This cloth has clearly been worn a great deal; the fragile silk threads show the greatest wear.

30
Wrapper
Asante people, Ghana

Cotton and rayon plain weave
 with rayon supplementary
 weft
74⅞ x 32¼ in. (190.2 x 83.2 cm)
Purchased with funds provided
 by the Smithsonian Institution
 Collection Acquisition
 Program, 1983−85
Lamb 200 GA
Purchased in Bonwire, Ghana,
 in 1971

Materials
Ground warp: cotton machine-
 spun S-twist, dark blue, white
Ground weft: cotton machine-
 spun S-twist, dark blue, white
Complementary weft: cotton
 machine-spun S-twist, white;
 rayon machine-spun Z-twist,
 brown, yellow, red, green,
 blue
Supplementary weft: rayon
 machine-spun Z-twist, yellow,
 red, green

Techniques
Balanced and weft-faced plain
 weaves with discontinuous
 supplementary weft
Proportions: 1 warp to 1 weft
Thread count: warp 82 per in.
 (32 per cm); weft 62−135 per
 in. (24−53 per cm)
Complementary and
 supplementary wefts pass over
 and under 6 warps

Ten panels handsewn at
 selvedges; selvedge to selvedge
 width 3¼ in. (8.3 cm)
Fringe: warp ends unworked;
 length ⅜ in. (1 cm)

Published
Venice Lamb, *West African
 Weaving* (London: Duckworth
 Press, 1975), 117, fig. d.

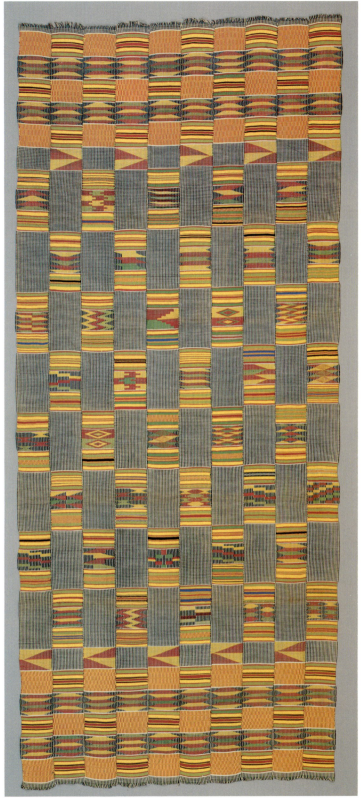

Text on next page.

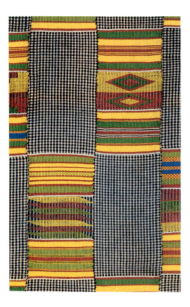

This cloth displays a wonderful contrast of delicate indigo and white background striping with brilliant color highlights. In the colored blocks, stripes are not used in the ground weft; thus, there is a plain warp-striped background instead of checks. The weaver perhaps felt that the checks used in the rest of the cloth were too busy to be the background for the colored patterns. The checkerboard arrangement is strictly followed, and the composition is firmly stopped at each end with a rhythmic border pattern. When such a cloth is worn, the differentiated border adds further elaboration to an already highly decorative costume.

The colored supplementary blocks and end borders are composed of three major patterns. The *babadua* pattern is a series of weft-faced bands, often delineated on the top and bottom with a narrow white band. Another pattern, *nwatoa*, is usually made up of small alternating blocks of red and yellow. As seen in this cloth, it is used only in end borders, often in combination with *babadua*. The word *nwatoa* derives from *nwa*, "to sew," and *toa*, "to join" (Bishopp 1977, 22). A third type of pattern found in this cloth is called *akyem*, "the shield" (Bishopp 1977, 23), formed of contrasting colors in a shield shape. It is usually found in end borders, as in this piece, but it may also appear in the central field.

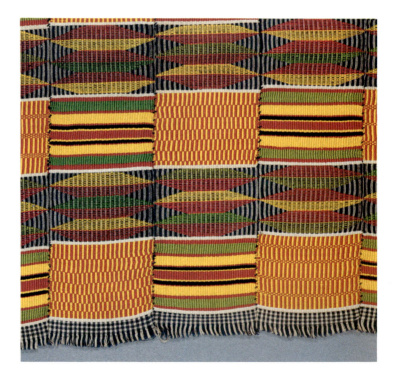

31
Wrapper
Asante people, Ghana

Cotton and silk plain weave
 with cotton and silk
 supplementary weft
62⅝ x 39⅞ in. (159.1 x 101.3 cm)
Purchased with funds provided
 by the Smithsonian Institution
 Collection Acquisition
 Program, 1983–85
Lamb 304 GA
Purchased in Bonwire, Ghana,
 in 1969

Materials
Ground warp: cotton machine-
 spun S-twist, red, yellow,
 green, dark blue, white
Ground weft: cotton machine-
 spun S-twist, red, white, dark
 blue
Complementary weft: cotton
 machine-spun S-twist, white,
 red, light blue, light green,
 yellow, dark blue
Supplementary weft: cotton
 machine-spun S-twist, red,
 light blue, light green, yellow,
 dark blue
Complementary and
 supplementary wefts:
 unraveled silk machine-spun
 S-twist, light yellow

Techniques
Warp- and weft-faced plain
 weaves with discontinuous
 supplementary weft
Proportions: 1 warp to 1 weft
Thread count: warp 90 per in.
 (35 per cm); weft 52 per in.
 (21 per cm)
Complementary and
 supplementary weft singles
 (yellow) and pairs pass over
 and under 4 and 8 warps
Thirteen panels handsewn at
 selvedges; selvedge to selvedge
 width 3–3⅜ in. (7.6–8.6 cm)
Top and bottom edges hand-
 hemmed

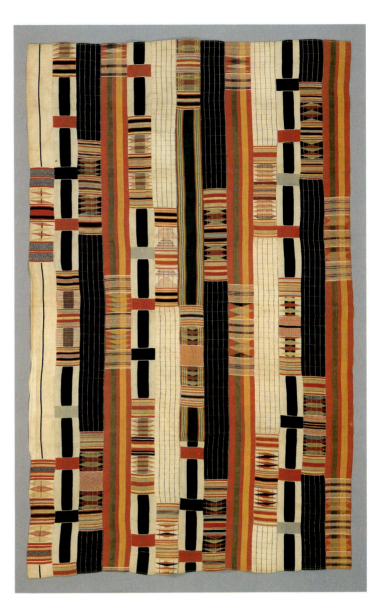

The placement of the pattern blocks and the order of the background stripes in this cloth typify the asymmetrical nature of West African textile design. The yellow silk in the piece was unraveled from an imported cloth (see cat. nos. 26 and 28).

32
Wrapper
Asante people, Ghana

Silk plain weave with silk
 supplementary weft
96 x 52½ in. (243.8 x 133.4 cm)
Purchased with funds provided
 by the Smithsonian Institution
 Collection Acquisition
 Program, 1983–85
Lamb 242 GA
Purchased in Bonwire, Ghana,
 in 1971

Materials
Ground warp: silk machine-
 spun Z-twist, green, light
 green
Ground weft: silk machine-spun
 Z-twist, light green
Complementary weft: silk
 machine-spun Z-twist, white,
 brown, red, yellow, light blue
Supplementary weft: silk
 machine-spun Z-twist, red,
 yellow

Techniques
Warp- and weft-faced plain
 weaves with discontinuous
 supplementary weft
Proportions: 1 warp to 1 weft
Thread count: warp 85 per in.
 (34 per cm); weft 45 per in.
 (18 per cm)
Complementary wefts and
 supplementary weft pairs pass
 over and under 6 warps

Sixteen panels handsewn at
 selvedges; selvedge to selvedge
 width 3½ in. (8.9 cm)
Top and bottom edges hand-
 hemmed

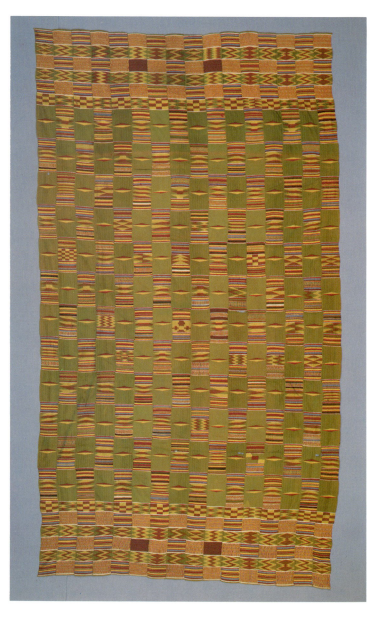

This cloth is woven completely of silk. The thread is commercially made and probably commercially dyed. Each of the large rectangular blocks with weft bands contains a different center pattern, known as *adwin,* "design" (Bishopp 1977, 23). The *adwin* pattern, along with the *babadua* and *nwatoa* patterns, is common in Asante cloths (see cat nos. 30 and 36). To construct a pattern, each weft thread is drawn through the shed by hand, greatly increasing both the time needed to finish the weaving and the cost. The alternating plain-colored areas feature a small motif named *makowa,* "the little pepper." The design is "woven at intervals to represent red and yellow peppers. Lesser chiefs might wear this pattern. The warp consists entirely of green threads" (Rattray 1927, 238).

33
Wrapper
Asante people, Ghana

Silk plain weave with silk
 supplementary weft
81⅞ x 49⅝ in. (208 x 126 cm)
Purchased with funds provided
 by the Smithsonian Institution
 Collection Acquisition
 Program, 1983–85
Lamb 285 GA
Purchased in Bonwire, Ghana,
 1969

Materials
Ground warp: silk machine-
 spun Z-twist, yellow-green,
 red, yellow, black, white, light
 blue
Ground weft: silk machine-spun
 Z-twist, dark blue, yellow-
 green, light blue, red
Complementary weft: silk
 machine-spun Z-twist, yellow,
 red, yellow-green, dark blue,
 white, light blue
Supplementary weft: silk
 machine-spun Z-twist, yellow,
 red, yellow-green, dark blue,
 light blue

Techniques
Warp- and weft-faced plain
 weaves with discontinuous
 supplementary weft
Proportions: 1 warp to 1 weft
Thread count: warp 92 per in.
 (36 per cm); weft 38 per in.
 (15 per cm)
Complementary wefts and
 supplementary weft pairs pass
 over and under 8 warps
Sixteen panels handsewn at
 selvedges; selvedge to selvedge
 width 3–3½ in. (7.6–8.9 cm)
Fringe: warp ends unworked;
 length ½–1 in. (1.3–2.5 cm)

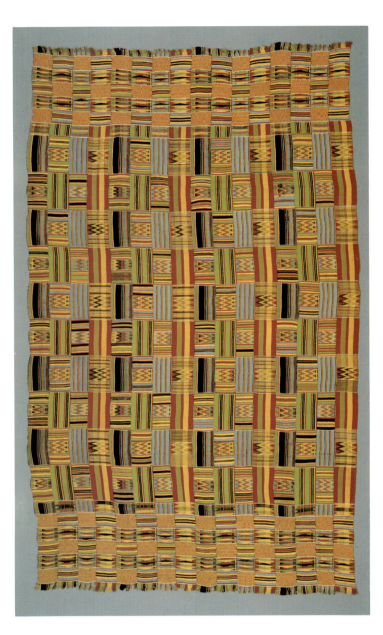

Dramatic background striping and colorful blocks make this
an extraordinary cloth. Although the zigzag is the only design
between the weft bands, four alternating warp patterns and
variations on the zigzag give the cloth a great vitality. The
warp pattern with bold red, green, and yellow stripes is
known as *oyokoman ogya da mu*, "there is fire between the
two factions of the Oyoko clan." It refers to "the civil war
after the death of Osai Tutu between Opoku Ware and the
Dako [c. 1730]. This [type of] cloth was worn by the King of
Ashanti" (Rattray 1927, 238).

34
Wrapper
Ewe people,
Volta region, Ghana

Cotton and rayon plain weave
with cotton and rayon
supplementary weft
79⅜ x 49 in. (201.6 x 124.5 cm)
Purchased with funds provided
by the Smithsonian Institution
Collection Acquisition
Program, 1983−85
Lamb 506 GA
Purchased in Anfoega, Ghana,
in 1972

Materials
Ground warp: cotton machine-
spun Z-twist, dark blue,
white, blue
Ground weft: cotton machine-
spun Z-twist, dark blue, red,
yellow; rayon machine-spun
Z-twist, green, blue
Complementary weft: cotton
machine-spun Z-twist, white
Supplementary weft: cotton
machine-spun Z-twist, white;
rayon machine-spun Z-twist,
yellow, red, green

Techniques
Balanced, warp-faced, and weft-
faced plain weaves with
discontinuous supplementary weft
Proportions: 2 warps to 2 wefts
Thread count: warp pairs 55 per
in. (22 per cm); weft pairs 32
per in. (13 per cm)
Complementary weft pairs and
supplementary weft bundles
of 6 pass over and under 4
warps
Twelve panels handsewn at
selvedges; selvedge to selvedge
width 4⅛ in. (10.5 cm)
Fringe: warp ends unworked;
length ⅜ in. (1 cm)

Published
Venice Lamb, *West African
Weaving* (London: Duckworth
Press, 1975), 199, fig. 281.
Venice and Alastair Lamb, *West
African Narrow Strip Weaving*
(Washington, D.C.: Textile
Museum, 1975), 47, figs. 58
and 59.

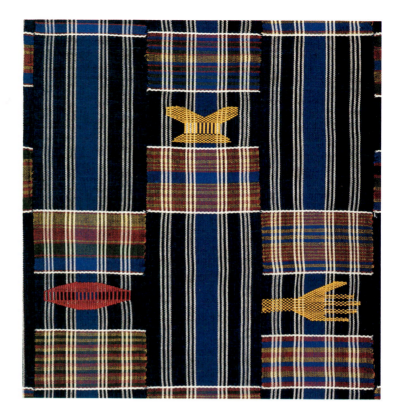

The Lambs had this cloth woven for them. They note that the cloth copies older Ewe patterns. The weaver used "as many figurative pictures as he could. He placed the figures between . . . blocks which are in tabby [plain weave] not inlay [supplementary weft]." They add that the borders are called *susuvu*, the Ewe equivalent of the Asante *adweneasa*, "my skill is exhausted" (see cat. no. 36).

Modern Ewe weavers create large numbers of Asante-style cloths for the burgeoning market. On the whole, Ewe cloths are more subtle than those of the Asante. This cloth has the blue and white striped background and banded blocks edged in white that are typical of Asante weaving. But the blocks are neither as vibrantly colored nor as visually dominant as in Asante cloths. The densely woven motifs between the blocks, on the other hand, are stronger in color; unlike an Asante cloth, this cloth focuses attention on the motifs rather than the banded blocks. Given the importance the Ewe attach to the motifs, this design emphasis is appropriate. Finally, this cloth has banded borders at each end, another Asante device.

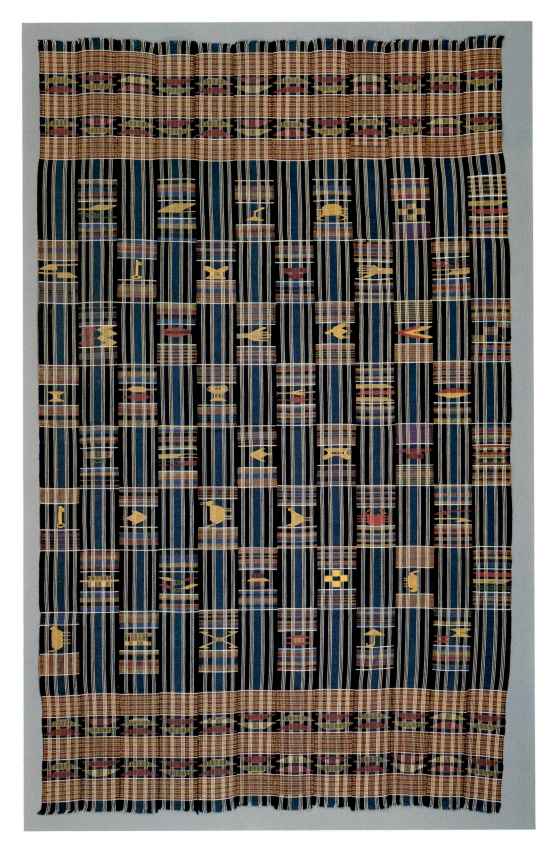

35
Wrapper
Ewe people, Ghana

Cotton plain weave with cotton
supplementary weft
105¼ x 74⅛ in. (267.3 x 188.3
cm)
Gift of Cynthia E. Gubernick,
1970
National Museum of African
Art, 70-20-78

Materials
Ground warp: cotton machine-
spun S-twist, dark blue, tan;
cotton machine-spun Z-twist,
red
Ground weft: cotton machine-
spun Z-twist, dark blue;
cotton machine-spun S-twist,
tan
Complementary weft: cotton
machine-spun S-twist, white;
cotton machine-spun Z-twist,
red, tan, green, light green,
dark blue, yellow
Supplementary weft: cotton
machine-spun S-twist, tan,
dark yellow; cotton machine-
spun Z-twist, light blue-green

Techniques
Warp- and weft-faced plain
weaves with discontinuous
supplementary weft
Proportions: 1 and 2 warps to 1
weft
Thread count: warp pairs 65 per
in. (26 per cm); weft 40 per
in. (16 per cm)
Complementary and
supplementary wefts pass over
and under 4 and 6 warps
Twenty panels handsewn at
selvedges; selvedge to selvedge
width 3¾ in. (9.5 cm)
Top and bottom edges hand-
hemmed

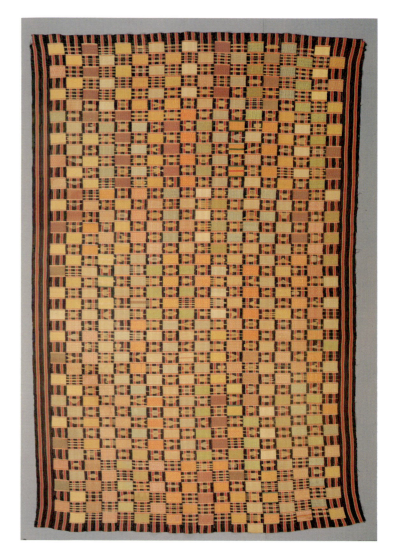

The decorative qualities of Ewe and Asante cloths may
initially appear identical, but closer examination reveals
distinctive differences. With fewer variations in the
composition, the overall effect of an Ewe cloth is more
unified. The composition of this piece, for example, is
controlled by smaller, less dramatic units than are usually
found in Asante weaving. The rectangular blocks that form
the checkerboard design, composed of subtly changing colors,
lack the white outline to set them apart from the background
warp stripes. In some blocks, red and tan threads were plied
together before weaving to create a tweedlike effect. Often
found in Ewe cloths, this technique is not used by Asante
weavers. The rich design of this piece distinguishes it as a
susuvu cloth (see cat. no. 34).

36
Wrapper
Asante people, Ghana

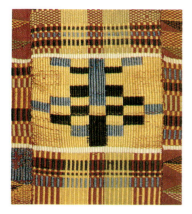

Cotton and silk plain weave
 with silk supplementary weft
46⅛ x 16⅞ in. (117.2 x 42.9 cm)
Purchased with funds provided
 by the Smithsonian Institution
 Collection Acquisition
 Program, 1983–85
Lamb 278 GA
Purchased in Bonwire, Ghana,
 in 1969

Materials
Ground warp: cotton machine-
 spun Z-twist, red, light green,
 yellow
Ground weft: cotton machine-
 spun S-twist, light red
Complementary weft: silk
 machine-spun Z-twist, white
Supplementary weft: silk
 machine-spun Z-twist, white,
 blue, brown, light green,
 green

Techniques
Warp- and weft-faced plain
 weaves with discontinuous
 supplementary weft
Proportions: 1 warp to 1 weft
Thread count: warp 52 per in.
 (21 per cm); weft 45 per in.
 (18 per cm)
Complementary wefts and
 supplementary weft singles
 and pairs pass over and under
 4 warps
Five panels handsewn at
 selvedges; selvedge to selvedge
 width 3⅜ in. (8.6 cm)
Fringe: warp ends unworked;
 length 1½–1¾ in. (3.8–4.4 cm)

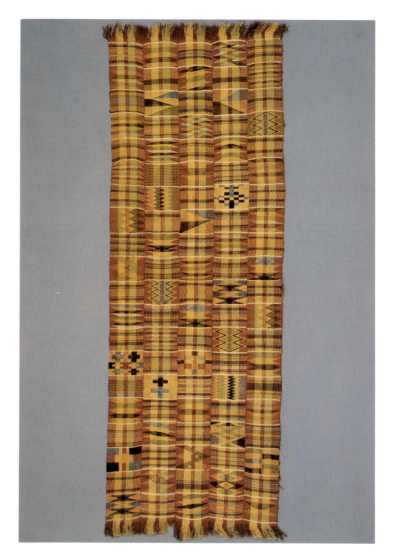

Weft designs cover the entire background of this cloth. The intricate composition, called *adweneasa,* "my skill is exhausted" or "my ideas have come to an end," requires three pairs of heddles to weave. The designs are usually restricted to alternating *nwatoa* and *adwin,* eliminating the more easily executed *babadua* bands (see cat. nos. 30 and 32). The cloth "is one of the best known in Ashanti, and weavers who can make it are considered masters of their craft" (Rattray 1927, 237). This type of cloth is also known as *asasia.* The term, however, is sometimes restricted to cloth that employs twill weave, which is not present in this piece. *Adweneasa* cloth, the most prestigious of the Asante cloths, was once reserved for the Asantehene and his close associates. The Bonwirehene, chief of the royal weaving town, controlled production (Bishopp 1977, 24). This particular cloth, possibly cut from a larger cloth, is identified by the Lambs as a woman's scarf (see cat. no. 27).

Glossary

Balanced plain weave. The size and spacing of the warps are approximately the same as the size and spacing of the wefts.

Braid. An obliquely interlaced trim formed of elements worked over and under one another.

Complementary wefts. Two or more sets of coequal wefts that are part of the ground weave.

Continuous supplementary weft. A weft added over the ground weave and carried from selvedge to selvedge.

Discontinuous supplementary weft. A weft added over the ground weave in a limited area for patterning. It is not carried to the selvedges.

Embroidery. Threads worked into an already woven ground fabric with a needle or other tool.

Float. The portion of a warp or weft element that crosses, or floats, over two or more units of the opposite set.

Furnishing fabric. A cloth that may be used as a domestic space divider, a cover for furniture, a cover for the floor, or a camel blanket, but not as clothing.

Ground weave. The basic woven structure of a cloth.

Inserted weft. Additional weft threads inserted in the structure in such a way that they deflect the ground weave.

Plain weave. A basic weave in which each weft thread passes over one and under one warp thread.

Selvedge. The warpwise edge of a textile in which wefts encircle the outer warp threads.

Spin. The direction in which individual weaving threads are twisted as the thread is formed. The letters *S* and *Z* are used to indicate the direction of spin.

Supplementary weft. Nonstructural weft added over the ground weave to create a pattern.

Tapestry weave. The linking together of wefts of adjacent color areas each time they meet.

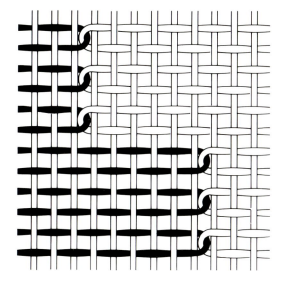

Thread count. The number of threads per inch or per centimeter, warp by weft.

Treadle. A foot peddle used by weavers to control the movement of the heddles.

Twill weave. A type of float weave characterized by a diagonal alignment of the floats.

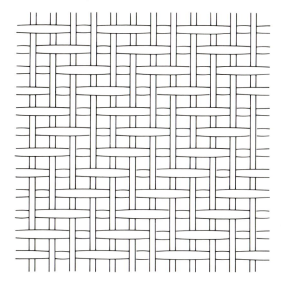

Twist. The action of twisting spun threads together. Usually the direction of the twist is the opposite of spin.

Unreeled silk. The single filament that is extracted from a silkworm's cocoon.

Warp. The longitudinal threads of a textile. The warp threads are arranged on the loom.

Warp-faced weave. Weave in which the warp predominates on the face of the textile, more or less concealing the weft.

Waste silk. Loose filaments at the core of a silkworm's cocoon that remain after the single filament has been unreeled.

Weft. The transverse threads of a textile. Weft threads are passed through the warp sheds and thus over and under the warp threads.

Weft-faced weave. Weave in which the weft predominates on the face of the textile, more or less concealing the warp.

Weft wrapping. Weft threads are carried manually over a group of warps and then wrapped around part of the group.

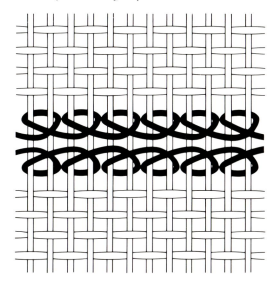

Wrapper. A cloth that is wrapped around the body, not cut and sewn to fit.

Bibliography

Abitbol, Michel. 1979. "Juifs Maghrebins et commerce transsaharien du VIIIe au XV siècle." *Révue française d'histoire d'outre-mer* 66:177–93.

———. 1982. "Juifs Maghrebins et commerce transsaharien au moyen-âge." In *Communautés juives des marges sahariennes du Maghreb,* edited by Michel Abitbol. Jerusalem: Université Hébraïque de Jerusalem.

Adamu, Mahdi. 1978. *The Hausa Factor in West African History.* Ibadan, Nigeria: Oxford University Press.

———. 1984. "The Hausa and Their Neighbors in the Central Sudan." In *General History of Africa.* Vol. 4, *Africa from the Twelfth to the Sixteenth Century,* edited by D. T. Niane. Berkeley: University of California Press.

Andah, B. Wai. 1981. "West Africa before the Seventh Century." In *General History of Africa.* Vol. 2, *Ancient Civilizations of Africa,* edited by G. Mokhtar. Berkeley: University of California Press.

Anderson, Jean. 1969. *Henry the Navigator, Prince of Portugal.* Philadelphia: Westminster Press.

Anquandah, James. 1982. *Rediscovering Ghana's Past.* Accra: Sedco Publishing.

Ardouin, Claude D., and Georges Meurillon. 1985. "La perte de technologie: Le cas du tissage de la laine dans le Delta Central du Niger." Paper presented at international seminar, Le rapport entre ville et campagne en Afrique occidentale et le transfert de technologie, Bamako, Mali.

Ball, J. N. 1977. *Merchants and Merchandise: The Expansion of Trade in Europe, 1500–1630.* New York: St. Martin's Press.

Bedaux, Rogier M. A., and Rita Bolland. 1980–81. "Medieval Textiles from the Tellem Caves in Central Mali." *Textile Museum Journal* 19–20:65–74.

Bishopp, Gregory James. 1977. "A Comparison of the Social and Aesthetic Role of Asante and Anlo Ewe Narrow Strip Weaving." Master's thesis, University of California, Santa Barbara.

Blake, John W. 1937. *European Beginnings in West Africa: 1454–1578.* Westport, Connecticut: Greenwood Press.

Boahen, A. Adu. 1968. "The Caravan Trade in the Nineteenth Century." In *Problems in Africa,* edited by Robert Collins. Englewood Cliffs, New Jersey: Prentice-Hall.

Boser-Sarivaxévanis, Renée. 1972. *Les tissus de l'Afrique occidentale.* Basel: Pharos-Verlag Hansrudolf Schwabe AG.

———. 1977. *Récherche sur l'histoire des textiles traditionnels tissés et tients de l'Afrique occidentale.* Basel: Verhandlungen der Naturforschenden Gesellschaft.

———. 1980. *West African Textiles and Garments.* Minneapolis-St. Paul: University of Minnesota.

———. 1985–86. "Notes on the Lamb Collection of West African Weaving." National Museum of African Art, Washington, D.C. Photocopy.

Bovill, E. W. 1958. *The Golden Trade of the Moors.* London: Oxford University Press.

Bowdich, Thomas Edward. [1819] 1966. *Mission from Cape Coast Castle to Ashantee.* Reprint, with notes and an introduction by W. E. F. Ward. London: Frank Cass.

Boxer, C. R. 1969. *Four Centuries of Portuguese Expansion, 1415–1825: A Succinct Survey.* Berkeley: University of California Press.

Bravmann, René A. 1974. *Islam and Tribal Art in West Africa.* Cambridge: Cambridge University Press.

———. 1986. "On Reading a Fragment of History—Dupuis' Portrait of Asantehene Osei Bonsu." Paper presented at the twenty-ninth annual meeting of the African Studies Association, Madison, Wisconsin.

Browne, Angela W. 1983. "Rural Industry and Appropriate Technology: The Lessons of Narrow-Loom Ashanti Weaving." *African Affairs* 82 (326): 29–41.

Cawston, George, and A. H. Keane. 1968. *The Early Chartered Companies (A.D. 1296–1858).* New York: Burt Franklin.

Chaudhuri, K. N. 1978. *The Trading World of Asia and the English East India Company.* Cambridge: Cambridge University Press.

Chouraqui, André. 1985. *Histoire des juifs en Afrique du nord.* Paris: Hachette Littérature.

Cole, Herbert M., and Doran H. Ross. 1977. *The Arts of Ghana.* Los Angeles: Museum of Cultural History, University of California.

Conrad, David, and Humphrey Fisher. 1982. "The Conquest that Never Was: Ghana and the Almoravids, 1076." Part 1. *History in Africa* 9:21–59.

Coombs, Douglas. 1963. *The Gold Coast, Britain and the Netherlands: 1850–1874.* London: Oxford University Press.

Crowfoot, Grace M. 1924. "The Handspinning of Cotton in the Sudan." *Sudan Notes* 7 (pt. 2): 83–89.

Curtin, Philip D. 1967. "Foreword to Part I." In *Africa Remembered,* edited by Philip D. Curtin. Madison: University of Wisconsin Press.

———. 1984. *Cross-Cultural Trade in World History.* Cambridge: Cambridge University Press.

Davidson, Basil. 1974. *Africa in History: Themes and Outlines.* New York: Macmillan.

Davies. K. G. 1957. *The Royal African Company.* London: Longmans, Green.

Desanges, J. 1981. "The Proto-Berbers." In *General History of Africa.* Vol. 2, *Ancient Civilizations of Africa,* edited by G. Mokhtar. Berkeley: University of California Press.

Dieterlen, Germaine. 1972. "Contribution à l'étude des relations historiques entre le Mande

et l'actuel Ghana." Paper presented at the Conference on Manding Studies/Congrès d'Etudes Manding, School of Oriental and African Studies, London.

Dyer, Mark. 1979. *Central Saharan Trade in the Early Islamic Centuries (7th–9th Centuries A.D.)*. Boston: African Studies Center, Boston University.

Fage. John D. 1961. *An Introduction to the History of West Africa*. Cambridge: Cambridge University Press.

———. 1964. "Some Thoughts on State-Formation in the Western Sudan Before the Seventeenth Century." Boston University Papers in African History, 19–34.

Fernandes, Valentim. 1951. *Déscription de la côte occidentale d'Afrique (Sénégal au Cap de Monte, Archipels)*. Edited by Th. Monod, A. Teixeira da Mota, and R. Mauny. Bissau: Centro de Estudos da Guiné Portuguesa.

Fraser, Douglas. 1974. *African Art as Philosophy*. New York: Interbook.

Fyfe, Christopher. 1964. *Sierra Leone Inheritance*. London: Oxford University Press.

Fyle, C. Magbaily, and Arthur Abraham. 1976. "The Country Cloth Culture in Sierra Leone." *Odu*, n.s. no. 13:104–11.

Fynn, J. K. 1971. *Asante and Its Neighbors, 1700–1807*. Evanston: Northwestern University Press.

Gabus, Jean. 1955. *Au Sahara*. Vol. 1, *Les hommes et leurs outils*. Neuchâtel: A la Baconnière.

Gamble, David P. 1957. *The Wolof of Senegambia*. London: International African Institute.

Gardi, Bernhard, 1985. *Ein Markt wie Mopti*. Basel: Ethnologisches Seminar der Universität und Museum für Völkerkunde.

Gilfoy, Peggy Stoltz. 1983. *Fabrics in Celebration from the Collection*. Indianapolis: Indianapolis Museum of Art.

Glamann, Kristof. 1958. *Dutch-Asiatic Trade: 1620–1740*. Copenhagen: Danish Science Press.

Goitien, S. D. 1954. "From the Mediterranean to India: Documents on the Trade to India, South Arabia and East Africa from the Eleventh to the Twelfth Centuries." *Speculum: A Journal of Medieval Studies* 29 (2): 181–97.

———. 1961. "The Main Industries of the Mediterranean Area as Reflected in the Records of the Cairo Geniza." *Journal of the Economic and Social History of the Orient* 4:168–97.

———. 1963. "Letters and Documents on the India Trade in Medieval Times." *Islamic Culture* 37:188–205.

———. 1964. "Artisans en Méditerranée oriental au haut moyen âge." *Annales: Economies, sociétés, civilisations* 19(5): 847–68.

Goody, Esther N. 1982. "Daboya Weavers: Relations of Production, Dependence and Reciprocity." In *From Craft to Industry*.

Cambridge: Cambridge University Press.

Greenberg, Joseph H. 1970. *The Languages of Africa*. Bloomington: Indiana University Press.

Griaule, Marcel. 1965. *Conversations with Ogotemmêli*. London: Oxford University Press.

Griffiths, Percival. 1974. *A License to Trade: The History of English Chartered Companies*. London: Ernest Benn.

Hakluyt, Richard. [1589] 1903–05. *The Principal Navigations, Voyages, Traffiques and Discoveries of the English Nation. . . .* Glasgow: J. MacLehose.

Hale, Sjarief. 1970. "Kente Cloth of Ghana." *African Arts* 3 (3): 26–29.

Hammond, Peter B. 1966. *Yatenga*. New York: Free Press.

Hess, Andrew. 1978. *The Forgotten Frontier: A History of the Sixteenth-Century Ibero-African Frontier*. Chicago: University of Chicago Press.

Hirschberg, H. Z. 1974. *A History of the Jews in North Africa*. Vol. 1, *From Antiquity to the Sixteenth Century*. Leiden: E. J. Brill.

Hodgkin, Thomas. 1975. *Nigerian Perspectives*. London: Oxford University Press.

Holas, Bohumil. 1949. "Note sur le vêtement et la parure baoulé." *Bulletin de l'institut français d'Afrique noire* 11 (3–4): 438–57.

Hrbek, I. 1984. "The Disintegration of Political Unity in the Maghrib." D. T. Niane. In *General History of Africa*. Vol. 4, *Africa from the Twelfth to Sixteenth Century*, edited by D. T. Niane. Berkeley: University of California Press.

Hull, Richard W. 1976. *African Cities before the European Conquest*. New York: Norton.

Ilevbare, J. A. 1980. *Carthage, Rome and the Berbers*. Ibadan, Nigeria: Ibadan University Press.

Imperato, Pascal James. 1973. "Wool Blankets of the Peul of Mali." *African Arts* 6 (3): 40–47.

———. 1974. "Bamana and Maninka Covers and Blankets." *African Arts* 7 (3): 56–67.

———. 1979. "Blankets and Covers from the Niger Bend." *African Arts* 12 (4): 38–43.

Johnson, Marion. 1972. "Manding Weaving." Paper presented at the Conference on Manding Studies/Congrès d'Etudes Manding, School of Oriental and African Studies, London.

———. 1973. "Cloth on the Banks of the Niger." *Journal of the Historical Society of Nigeria* 6 (4): 353–63.

———. 1976. "Calico Caravans: The Tripoli-Kano Trade after 1880." *Journal of African History* 17 (1): 95–117.

———. 1980. "Cloth as Money: the Cloth Strip Currencies of Africa." In *Textiles of Africa*, edited by Dale Idiens and K. G. Ponting. Bath, England: Pasold Research Fund.

———. 1983. "Periphery and the Centre: The 19th Century Trade of Kano." In *Studies in the History of Kano*, edited by Bawuro M. Barkindo. Nigeria: Heinemann Educational Books.

Johnston, H. A. S. 1967. *The Fulani Empire of Sokoto.* London: Oxford University Press.

Keenan, Jeremy. 1977. *The Tuareg.* London: Allen Lane.

Kent, Kate P. 1971. *Introducing West African Cloth.* Denver: Denver Museum of Natural History.

Kipre, Pierre. 1984. "From the Ivory Coast Lagoons to the Volta." In *General History of Africa.* Vol. 4, *Africa from the Twelfth to Sixteenth Century,* edited by D. T. Niane. Berkeley: University of California Press.

Klein, Martin A., and G. Wesley Johnson. 1972. *Perspective on the African Past.* Boston: Little, Brown.

Kup, A. P. 1961. *A History of Sierra Leone: 1400–1787.* Cambridge: Cambridge University Press.

Lamb, Venice. 1975. *West African Weaving.* London: Duckworth.

Lamb, Venice, and Alastair Lamb. 1980. "The Classification and Distribution of Horizontal Treadle Looms in Sub-Saharan Africa." In *Textiles of Africa,* edited by Dale Idiens and K. G. Pointing. Bath, England: Pasold Research Fund.

———. 1984. *Sierra Leone Weaving.* Hertingfordbury, England: Roxford Books.

Lange, D. 1984. "The Kingdoms and Peoples of Chad." In *General History of Africa.* Vol. 4, *Africa from the Twelfth to Sixteenth Century,* edited by D. T. Niane. Berkeley: University of California Press.

Latham, Norah. 1964. *The Heritage of West Africa.* London: Hulton Educational Publications.

Launay, Robert. 1982. *Traders Without Trade.* Cambridge: Cambridge University Press.

Law, R. C. C. 1978. "North Africa in the Period of Phoenician and Greek Colonization, c. 800 to 323 B.C." In *The Cambridge History of Africa.* Vol. 2, *From c. 500 B.C. to A.D. 1050,* edited by John D. Fage. Cambridge: Cambridge University Press.

Lawrence, A. W. 1964. *Trade Castles and Forts of West Africa.* Stanford: Stanford University Press.

Lestrange, Monique de. 1950. "Les Sarankolé de Badyar, technique de teinturiers." *Etudes guinéennes* 6:17–27.

Levtzion, Nehemia. 1978. "The Sahara and the Sudan from the Arab Conquest of the Maghrib to the Rise of the Almoravids." In *The Cambridge History of Africa.* Vol. 2, *From c. 500 B.C. to A.D. 1050,* edited by John D. Fage. Cambridge: Cambridge University Press.

———. 1982. "The Jews of Sijilmasa and the Saharan Trade." In *Communautés juives des marges sahariennes du Maghreb,* edited by Michel Abitbol. Jerusalem: Université Hébraïque de Jerusalem.

Levtzion, Nehemia, and J. F. P. Hopkins, eds. 1981. *Corpus of Early Arabic Sources for West African History.* Cambridge: Cambridge University Press.

Lubeck, Paul. 1983. "Industrial Labor in Kano: Historical Origins, Social Characteristics and Sources of Differentiation." In *Studies in the History of Kano,* edited by Bawuro M. Barkindo. Nigeria: Heinemann Educational Books.

McLeod, M. D. 1981. *The Asante.* London: British Museum Publications.

Major, Richard Henry. 1967. *The Life of Prince Henry of Portugal.* London: Frank Cass.

Mauny, Raymond. 1968. "The Gold Trade." In *Problems in African History,* edited by Robert Collins. Englewood Cliffs, New Jersey: Prentice-Hall.

———. 1978. "Trans-Saharan Contacts and the Iron Age in West Africa." In *The Cambridge History of Africa.* Vol. 2, *From c. 500 B.C. to A.D. 1050,* edited by John D. Fage. Cambridge: Cambridge University Press.

Miege, Jean-Louis. 1982. "Les juifs et le commerce transsaharien au dix-neuvième siècle." In *Communautés juives des marges sahariennes du Maghreb,* edited by Michel Abitbol. Jerusalem: Université Hébraïque de Jerusalem.

Moloney, Cornelius Alfred. 1889. "Cotton Interests, Foreign and Native, in Yoruba, and Generally in West Africa." *Journal of the Manchester Geographical Society* 5:255–76.

Morel, Edmund D. 1902. *Affairs of West Africa.* London: William Heinemann.

Moreland, W. H. 1925. "Indian Exports of Cotton Goods in the Seventeenth Century." *Indian Journal of Economics* 5 (pt. 3): 225–45.

Mota, Avelino Teixeira da. 1972. "The Mande Trade in Costa da Mina according to Portuguese Documents until the Mid-Sixteenth Century." Paper presented at the Conference on Manding Studies/Congrès d'Etudes Manding, School of Oriental and African Studies, London.

———. 1976. *Some Aspects of Portuguese Colonisation and Sea Trade in West Africa in the 15th and 16th Centuries.* Bloomington: African Studies Program, Indiana University.

Murdock, George Peter. 1959. *Africa: Its Peoples and Their Culture History.* New York: McGraw-Hill.

Niane, D. T. 1984. "Mali and the Second Mandingo Expansion." In *General History of Africa.* Vol. 4, *Africa from the Twelfth to Sixteenth Century,* edited by D. T. Niane. Berkeley: University of California Press.

Park, Mungo. 1799. *Travels in the Interior Districts of Africa.* London: Bulmer.

Person, Yves. 1972. "The Dyula and the Manding World." Paper presented at the Conference on Manding Studies/Congrès d'Etudes Manding, School of Oriental and African Studies, London.

———. 1982. "Les Manding dans l'histoire." In

Etudes africaines: offerts à Henri Brunschwig. Paris: Editions de l'Ecole des Hautes Etudes en Sciences Sociales.

Picton, John, and John Mack. 1979. *African Textiles.* London: British Museum.

Polanyi, Karl. 1975. "Traders and Trade." In *Ancient Civilization and Trade,* edited by Jeremy Sabloff and C. C. Lamberg. Albuquerque: University of New Mexico Press.

Posnansky, M. 1981. "Introduction to the Later Prehistory of Sub-Saharan Africa." In *General History of Africa.* Vol. 2, *Ancient Civilizations of Africa,* edited by G. Mokhtar. Berkeley: University of California Press.

———. 1981. "The Societies of Africa South of the Sahara in the Early Iron Age." In *General History of Africa.* Vol. 2, *Ancient Civilizations of Africa,* edited by G. Mokhtar. Berkeley: University of California Press.

Priestley, Margaret. 1967. "Philip Quaque of Cape Coast." In *Africa Remembered,* edited by Philip D. Curtin. Madison: University of Wisconsin Press.

Prussin, Labelle. 1986. *Hatumere: Islamic Design in West Africa.* Berkeley: University of California Press.

Quinn, Charlotte A. 1972. *Mandingo Kingdoms of Senegambia: Traditionalism, Islam, and European Expansion.* Evanston: Northwestern University Press.

Rattray, R. S. 1923. *Ashanti.* Oxford: Clarendon Press.

———. 1927. *Religion and Art in Ashanti.* Oxford: Clarendon Press.

Rodney, Walter. 1970. *A History of the Upper Guinea Coast: 1545–1800.* Oxford: Clarendon Press.

Roth, H. Ling. 1918. *Studies in Primitive Looms.* Halifax, England: Bankfield Museum.

Sagnia, B. K. 1984. *Manding Indigenous Industries: A Casestudy of the Historical Background, Nature of Dissemination and Production Technique of Manding Weaving in the Senegambia Region.* Occasional Publications of the Gambia National Museum, vol. 5. Banjul, Gambia: Museum and Antiquities Division.

Santos, Maria Emília Madeira. 1978. *Viagems de exploração terrestre dos Portugueses em Africa.* Lisbon: Centro de Estudos de Cartografia Antiga.

Schwab, George. 1947. *Tribes of the Liberian Hinterland.* Cambridge, Massachusetts: Peabody Museum.

Shea, Philip J. 1974–77. "Economies of Scale and the Indigo Dyeing Industry of Precolonial Kano." *Kano Studies* 1 (2): 55–61.

———. 1980. "Kano and the Silk Trade." *Kano Studies* 2 (1): 96–112.

Sieber, Roy. 1972. *African Textiles and Decorative Arts.* New York: Museum of Modern Art.

Silverman, Raymond Aaron. 1983. "History, Art and Assimilation: The Impact of Islam on Akan Material Culture." Ph.D. diss., University of Washington, Seattle.

———. 1986. "Dress for Success: Imaging the Gods of the Akan." Paper presented at the twenty-ninth annual meeting of the African Studies Association, Madison, Wisconsin.

Skinner, Elliott P. 1964. *The Mossi of the Upper Volta.* Stanford: Stanford University Press.

Smith, Shea Clark. 1975. "Kente Cloth Motifs." *African Arts* 9 (1): 36–39.

Steensgard, Niels. 1974. *The Asian Trade Revolution of the Seventeenth Century.* Chicago: University of Chicago Press.

Steiner, Christopher. 1985. "Another Image of Africa: Toward an Ethnohistory of European Cloth Marketed in West Africa, 1873–1960." *Ethnohistory* 32 (2): 91–110.

Talbi, M. 1984. "The Spread of Civilization in the Maghrib and Its Impact on Western Civilization." In *General History of Africa.* Vol. 4, *Africa from the Twelfth to Sixteenth Century,* edited by D. T. Niane. Berkeley: University of California Press.

Vogt, John. 1975. "Notes on the Portuguese Cloth Trade in West Africa, 1480–1540." *International Journal of African Historical Studies* 8 (4): 623–49.

———. 1979. *Portuguese Rule on the Gold Coast.* Athens: University of Georgia Press.

Warmington, B. H. 1969. *Carthage.* New York: Frederick A. Praeger.

———. 1981. "The Carthaginian Period." In *General History of Africa.* Vol. 2, *Ancient Civilizations of Africa,* edited by G. Mokhtar. Berkeley: University of California Press.

Warren, Dennis M. 1975. "Bono Royal Regalia." *African Arts* 8 (2): 16–21.

Watson, Andrew M. 1977. "The Rise and Spread of Old World Cotton." In *Studies in Textile History,* edited by Veronika Gervers. Toronto: Royal Ontario Museum.

Wheeler, Mortimer. 1953. *Rome Beyond the Imperial Frontiers.* Westport, Connecticut: Greenwood Press.

Wilks, Ivor. 1961. *The Northern Factor in Ashanti History.* Lagos: Institute of African Studies, University College of Ghana.

———. 1967. "Salih Bilali of Massina." In *Africa Remembered,* edited by Philip D. Curtin. Madison: University of Wisconsin Press.

———. 1968. "A Medieval Trade-Route from the Niger to the Gulf of Guinea." In *Problems in African History,* edited by Robert Collins. Englewood Cliffs, New Jersey: Prentice-Hall.

Winterbottom, Thomas. [1803] 1969. *An Account of the Native Africans in the Neighbourhood of Sierra Leone.* Reprint, with an introduction by John D. Hargreaves and E. Maurice Backett. London: Frank Cass.

PATTERNS OF LIFE

Designed by Christopher Jones

Studio photographs by Franko Khoury

Typeset in Meridien by
Barton Graphics in Hyattsville, Maryland

Printed on Mohawk Superfine and Vintage Velvet
by AmeriPrint in Vienna, Virginia